WILDLIFE PHOTOGRAPHY
A Field Guide

Eric Hosking is the world's most renowned bird photographer. Since he became a professional photographer in 1929, his photographs have appeared in books, magazines and newspapers throughout the world. A pioneer of the use of flash in bird photography, he has been awarded an honorary fellowship of the Photographic Society, the gold medal of the Royal Society for the Protection of Birds and the silver medal of the Zoological Society. His autobiography *An Eye for a Bird* was published by Arrow in 1973.

John Gooders is an internationally established ornithologist. His books include *Where to Watch Birds* (1967), *Where to Watch Birds in Europe* (1970), *Birds—an Illustrated Survey of the Bird Families of the World* (1975). He was also editor of the nine volume encyclopedia *Birds of the World* and contributes regularly to the BBC series *The World About Us*.

By ERIC HOSKING
Friends at the Zoo

WITH FRANK W. LANE
An Eye for a Bird
The autobiography of a bird photographer

WITH CYRIL NEWBERRY
Intimate Sketches from Bird Life
The Art of Bird Photography
Birds of the Day
Birds of the Night
More Birds of the Day
The Swallow
Birds in Action
Bird Photography

WITH HAROLD LOWES
Masterpieces of Bird Photography

WITH STUART SMITH
Birds Fighting

WITH WINWOOD READE
Nesting Birds, Eggs and Fledglings

BOOKS ILLUSTRATED (SELECTION)
Birds as Individuals *by Len Howard*
Bird Migrants *by Eric Simms*
Bird Migration *by Robert Spencer*
Bird Watching *by R. M. Lockley*
The Redstart *by John Buxton*
Wings of Light *by Garth Christian*
Portrait of a Wilderness *by Guy Mountfort*
Portrait of a River *by Guy Mountfort*
Portrait of a Desert *by Guy Mountfort*
The Vanishing Jungle *by Guy Mountfort*

By JOHN GOODERS
Where to Watch Birds
Where to Watch Birds in Britain and Europe
Birds of the World (*Nine Vols., Editor*)

Wildlife Photography

A Field Guide

Eric Hosking, Hon. FRPS, FHP
and John Gooders, B. Sc.

Arrow Books

Arrow Books Limited
3 Fitzroy Square, London W1

An imprint of the Hutchinson Publishing Group

London Melbourne Sydney Auckland
Wellington Johannesburg and agencies
throughout the world

First published Hutchinson & Co Ltd 1973
Arrow edition 1976
© Eric Hosking and John Gooders 1973

Filmset by BAS Printers Limited, Wallop, Hampshire

Made and printed in Great Britain
by The Anchor Press Ltd
Tiptree, Essex

ISBN 0 09 913740 2

Contents

Illustrations

IN BLACK AND WHITE

Between pages 32 and 33

A dozing leopard permits the photographer to change lenses

A Lake Manyara tree-climbing lion

A bean bag provides adequate support for even a long lens

An adult male lion walks between two safari minibuses

The approximate effect of different focal length lenses can be read off from this photograph of African elephants

Chinkara, the Asiatic gazelle, photographed in Pakistan

The black rhinoceros of Africa

Permanent viewing hide at the RSPB's Reserve at Minsmere, Suffolk

Great white egrets at their nest

Pair of bramblings at their nest in the crotch of a birch

Small pylon hide constructed of well-guyed alloy dexion

Two shots of sanderling taken by different 'wait and see' techniques

Cuckoo attracted by a cuckoo tape recording

Blue and great tits squabbling over fat and sunflower seeds lodged in a post

Between pages 96 and 97

A cock bearded tit visits his nest

Flat-bottomed boat being moved into position

Arctic tern

Masked booby

Pair of short-toed eagles at their nest, the Coto Doñana

Pylon hide improvised on site

Acknowledgements

In writing this guide we have received helpful advice from many people and we are grateful to them all. We would especially like to thank the following: Gerald Austin, Bert Axell MBE, Ian Beames, Sdeuard Bisserot, Hazel Cooper, Peggy Hadfield, Frank W. Lane, Kevin MacDonnell, Rodney Paull, Gordon Robinson, Peter Steyn, Graham Wainwright and John G. Williams.

Anyone who writes a book makes quite unreasonable demands on his family. Not only do they miss part of what in normal households is called 'family life', but they get roped in for all manner of strange and unaccustomed tasks. Thus our final thanks go to David and Dorothy Hosking and to Su Gooders for the services rendered quite outside the normal call of duty!

Authors' Introduction

Many books about natural history start with an introduction that tries to defend the publication of the book itself. We shall avoid such pedantry and simply confine ourselves to noting that wildlife photography has passed through a recent revolution and is on the verge of becoming a mass leisure pursuit.

Our aims are simple. We wish to help, instruct, teach and advise anyone and everyone with an interest in the subject, from the beginner on his first wildlife safari who recognises that it is better to shoot animals on film than shoot them dead, to the dedicated amateur struggling to improve his technique and know-how. For this reason we have made use of cross headings within each chapter, hopefully enabling the reader to find what he wants quickly. Checklists of equipment are included as Appendix A (page 165). The book is also designed to be read continuously and not simply as a work of reference, and as far as possible discursive material has been omitted.

In spite of everything written and illustrated here it is not yet possible to guarantee the reader's results—thank heaven. A good photograph is taken by a good photographer, and in the field of wildlife that means more than a good technician. It means above everything else understanding the subject not just in the bare bones text-book sense, or even in the scientific 'let's write a paper' sense, but properly and deeply through contact and observation in the field. Before you can obtain a decent photograph you should have an idea of what you want. Maybe it will be the greeting ceremony of the gannet, an elephant carrying the tusk of a dead jumbo into the bush, or aphids being milked by ants. All involve a knowledge of natural history, but a great photograph requires a deeper

knowledge not only so that the possibilities are recognised but also so that you set about taking it in the right way.

The wildlife photographer in the last quarter of the twentieth century could be forgiven for thinking that there was little left to photograph. We have seen standards rise so dramatically that many will be awed by previous achievements. This is a pity, first because there is as much choice of subject as there ever was and it is a mistake to think that previous standards cannot be bettered; and secondly because there is great enjoyment and satisfaction in photography for its own sake whether or not the results are better than, or even different from, what has been achieved before.

There are, of course, many subjects that have hardly been touched. The mammals and birds of the Amazon Basin come to mind along with many Asiatic species. We know of only one photographer who has photographed the snow leopard in the wild, so goodness knows how many insects and plants remain in the same area of the Himalayas, let alone elsewhere in the world. Less than half of the world's birds have been photographed and doubtless some photographer will discover some hitherto unknown and dramatic fact when he gets down to working one of them. Even the well photographed species still have aspects of their lives that remain unknown. Hole-nesting birds, for example, have parted with some of their secrets only over the last fifteen years. Heinz Sielmann looked into a woodpecker's nest and Alan Root into that of a hornbill with startling results. The Oxford Scientific Film unit has developed the filming of insects and smaller creatures via a whole battery of new techniques and skills. Others will follow, develop and look at 'well-worked' subjects in a completely new way. It does not really matter whether you use just an ordinary camera with no special equipment, or the most sophisticated modern apparatus so long as the subject you are portraying comes to no harm. The message is clear—if you want to do something new the world of wildlife awaits you, if you simply want to enjoy wildlife photography as a participant sport there is nothing stopping you.

E.H./J.G.

Wildlife Photography

1 Cameras and Equipment

Before deciding on camera and equipment it is crucial for the would-be wildlife photographer fully to investigate his needs, analyse his motives and perform a little crystal ball gazing.

The Finished Product

A starting point in this self-analysis is to decide what the finished results are for. Are they simply a personal record of experiences that are not to be forgotten? A series of shots of an early morning ringing expedition, the time we all found a rare warbler, or simply a picture of an animal that wafts us back through time to the holiday spent on an East African safari. Almost all pictures have this element of nostalgia, they encapsulate a time gone by instantly and are there for us to look back on when we will, jogging our memories and enabling us to re-live a past experience. There is no reason why this should not be the only motive for taking a picture but with most wildlife photographs there are other elements at work.

You may want your pictures not simply as a reminder but as part of a scientific documentation, to illustrate your field notebook or a paper in a learned journal. In this case you will probably need to work in black and white rather than in colour. You may wish to write an article for a popular magazine where colour printing is a possibility, or you may simply want pictures to hang on your walls or for submitting for exhibition.

Do you want portraits or action shots? Will you project the results for your friends, or will you build the transparencies into a polished talk and spend the winter months travelling the lecture-hall circuit? Do you want to sell your pictures, remembering that perhaps only one in ten thousand pictures

ever ends up in print? Perhaps you simply want to take pictures of wildlife without any pre-determined motive. Des Bartlett, one of the greatest of wildlife photographers, is so thrilled and exhilarated at actually making the exposure that he usually sends his ciné film straight to a television company, and does not see the results until they appear in a finished programme on the screen. In much the same way Niall Rankin, who was one of the greatest of all British nature photographers, went on long trips to the Antarctic taking his own boat and obtaining thousands of five by four inch glass negatives, most of which have never even been printed. Other, perhaps more normal, beings cannot wait to get into the dark-room or receive their film back from the processing laboratory. For them every step is exciting. Even professionals, and the number of people who make a full-time living from wildlife photography is incredibly small, must retain their enjoyment and excitement, for as soon as taking pictures becomes a chore it is best to stop.

Only after a thorough self-analysis can the photographer really begin to explore the possibilities of equipment and its suitability to his needs. Collect brochures, study the shop windows, go in and examine likely cameras without buying, talk to assistants—particularly if they seem knowledgeable—and eventually make up your mind and start the search for the best prices. All new equipment can be purchased at a discount somewhere and almost all equipment, except the very latest items, is available on the second-hand market. By and large, buying second-hand cameras is not like buying a second-hand car. Wind-on gears are never full of sawdust and optics are seldom fitted into place with chewing-gum. Cameras are seldom ill-treated and have generally been used with care simply to take pictures. Most reputable dealers offer a written guarantee for a period after purchase during which any faults should become apparent, but if you can afford new equipment buy it.

In the early 1960's there was an excited rush into 35mm equipment with everyone deciding that the miniature format offered the ultimate in wildlife equipment. Within ten years, more and more photographers were changing to the larger $2\frac{1}{4}''$

square (6cm × 6cm) format producing larger originals for better projection and reproduction. Now in the early 1970's there seems to be a swing back to 35mm once more. If these swings are taken to indicate a lack of complete satisfaction on the part of the experienced wildlife photographer then the beginner will at once appreciate that all photography is a matter of compromise, and that what ultimately counts is the use made of equipment by the man who releases the shutter.

Behind the swings is one basic assumption that will run through the rest of this book—that the photographer wants to produce colour transparencies. This, we are sure, will be a continuing trend in the forseeable future. Black and white will remain popular but will become increasingly the preserve of the enthusiast who wants to produce large prints for exhibition purposes. For all other uses: information storage, slide shows, lectures and reproduction in books and magazines, the future will increasingly revolve around colour—and colour transparencies at that.

Format

Ten to fifteen years ago we would have advocated the plate camera with an $8\frac{1}{2}''$ lens and a Luc shutter for a wide variety of wildlife subjects and as *de rigueur* for bird photography. Today we are not even sure whether the perfect animal portrait in black and white to be blown up and hung on a wall is best taken with such equipment. Certainly as far as colour is concerned the choice rests between 35mm and $2\frac{1}{4}''$ square cameras. Given the same degree of skill, the $2\frac{1}{4}''$ gives a larger transparency that most printers would be happy to reproduce, whereas many of them throw up their hands in horror at the idea of reproducing a whole page or a spread from a 35mm original. Those that can be persuaded to try it are usually highly satisfied, not to mention surprised, with the results. Some of the most professional magazines actually prefer the smaller format because of the very high quality of the film stock that is available. For many years the National Geographic

magazine of America has maintained that the best results are obtained from 35mm transparencies.

Though this aspect could be argued endlessly there is little doubt that the 35mm format is as 'professional' as any. It is cheaper to buy, cheaper to run, has the finest colour film in the world available for use, and a range of lenses and accessories second to none. Nevertheless, most professionals are currently using the $2\frac{1}{4}''$ square format though, to be sure, they have a 35mm outfit as well.

Cameras

Arguments over format have not resulted in a camera that can be used with either 35mm or $2\frac{1}{4}''$ square film, though equipment development has led to the non-obsolescent camera. This is the camera that comes to bits and can be put together again quickly and simply using the same or different parts. Bird photography, for example, can be divided into three categories each requiring a different set of equipment. There is the portrait of the bird at the nest; 'wait-and-see' where the photographer sits in a hide and waits at a likely spot for a subject to come within range; and stalking where the aim is to approach the subject without it flying away. A compromise can be reached by using a 35mm camera with a 250mm or 300mm lens but this will be found barely long enough for stalking and too long for photographing at the nest, where the photographer will have to work too far away to see the intimate details that he wants to record.

Thus the ideal wildlife photographer's camera is the one that comes apart, where the lens can be changed quickly and simply and where the manufacturer offers a whole range of lenses of different focal lengths. Lenses made by other manufacturers can, of course, often be adapted to different camera bodies. If possible this ideal camera should have interchangeable viewing systems suitable for different purposes, and a whole range of additional apparatus for specialised techniques.

Irrespective of attitude towards photography and the use that is made of the results, the need is for a basic outfit that will

enable wildlife pictures to be taken successfully. In our view a
35mm camera with a 250mm to 300mm lens is as basic as one
can get.

There is no doubt that a reflex camera is best for wildlife
subjects and a single-lens reflex (SLR) absolutely ideal. It is
fortunate that such cameras are proving ever more popular
and thus that a wider and cheaper choice is coming onto the
market. SLR cameras are available in 35mm and $2\frac{1}{4}''$ format.
Basically the design centres around a system that views the
subject through the same lens that will take the picture. Light
passing through the camera lens is focused on the film plane.
In an SLR camera a mirror intercepts the light and focuses it
on a glass screen until a fraction of a second before the exposure
is made. As the shutter is released the mirror springs clear and
the light passes through the camera to the film.

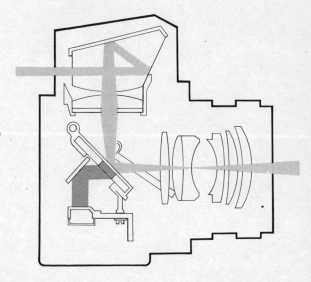

*Figure 1. Section through single lens reflex (SLR) camera with
pentaprism, showing light path and through-the-lens (TTL) metering
system*

This then is the single-lens-reflex camera used by almost all wildlife photographers. It has distinct advantages over all other types by enabling the photographer to see, via the mirror, exactly what he is going to take without any cut-off of part of the subject and without parallax problems. This is particularly important in those aspects of photography where either close-ups or the use of long lenses is essential—the very core of wildlife work. Parallax arises wherever the subject is not viewed through the taking lens, i.e. with any camera that uses a viewfinder system and with twin-lens-reflex cameras. When working at close range the picture seen through the viewfinder will not be the same as that taken because of the different viewpoint of lens and finder. Scales of compensation may be given on the side of the camera or it may even be coupled to compensate, but for close-up work viewing the subject directly has obvious advantages. In one twin-lens-reflex camera that focuses down to 9 inches a needle moves across the viewfinder to indicate that area of the subject that will be included. Unfortunately at minimum range only a fifth or so of the subject can actually be seen, composed and brought into focus.

SLR cameras then have one thing in common—a mirror that enables composition and focusing through the taking lens. After that they vary enormously. Some have an instant-return-mirror (IRM), where the mirror returns to its position, intercepting the light passing through the lens, as soon as the exposure is completed. Thus when making an exposure with an IRM the photographer simply sees a 'flicker' as the mirror springs up and instantly returns. Cameras without an IRM require the film to be wound on to re-set the mirror. One could argue advantage and disadvantage but most 35mm SLR's now have IRMs.

Similarly most SLR's utilise a focal plane shutter. A slit of variable size passes across the frame allowing light to reach the film as it does so. The width of the slit controls the 'speed' of the exposure i.e. the time that any part of the film remains uncovered. In some instances, as when using time exposures, the slit is opened right across the film width and remains open until released. Many focal plane shutters are made of fabric

not metal and are particularly prone to damage. While extremely accurate they are difficult to adjust.

The camera should have an adequate range of speeds for the purpose envisaged. Most 35mm SLRs have one second to 1/1000th but some only have 1/500th while others boast 1/2000th. The number of occasions that a 1/2000th can be used is extremely limited and we doubt whether the extra cost can be justified in terms of its use just a few times a year. A 1/1000th on the other hand is often essential to stop the movement of running mammals and flying birds and it is well worth obtaining a camera with this speed.

While fast speeds are important it must be remembered that really fast action shots, of flying hummingbirds for example, require high-speed flash lighting and the camera must, therefore, be synchronised for electronic flash.

Lenses

Though the camera should be as versatile as possible there is no doubt that the ultimate quality of the finished photograph depends more on the quality of the lens than on anything else. The camera is just a rather sophisticated black box. The light from the subject has to pass through the lens to the film.

If money is strictly limited, as much as possible should be spent on the lens. A lens that cost half a week's wages cannot be expected to produce the same results that can be obtained from a lens that costs twice as much.

Though some photographers seem to turn out good pictures through almost anything (including, it is said, the end of a beer bottle), cheap lenses are generally a waste of money, and it is better to save up until you can afford a really good one. Hunt the second-hand market for bargains rather than spend even a quarter of the amount on a lens that will not give you the results you require. In all cases, however, it is essential to insist on testing a second-hand lens before finally making the purchase.

With an expensive lens the photographer does not just get a larger aperture or automatic diaphragm, he demands and

obtains a fine image focused on the film. If you have a mass-produced cheap lens that you find perfectly satisfactory, try looking at the transparencies it produces against the sky with a magnifying glass. We use magnification to inspect every one of our transparencies when they are returned from processing; it is the only way to see if the subject has moved, whether there is camera shake and whether the subject is crisp and sharp. Projection is also useful but if perfection, or results that might be reproduced, is the aim, then critical examination is essential. Projection is, however, by far the best way of examining picture composition.

Many photographers are very proud of their wide aperture lens without thought as to its use. An f3·5 lens of 300mm is certainly an expensive job, but this focal length working at maximum aperture gives such a tiny depth of field, particularly when working at short range, that it is to be discouraged in most circumstances. There are altogether too many photographs that have a narrow band of focus separating unsightly blurs at the top and bottom of the picture. If, for instance, you take a shot of two ducks swimming one behind the other on your 300mm at f3·5 at thirty feet range, one will be in focus the other not. Similarly if you take a three-quarters view of a sparrow at nine feet the head will be in focus, the body mainly out of focus and the tail a blur.

As far as possible the lens should be stopped down to give maximum depth of field commensurate with the speed necessary to produce a sharp image. Never take a picture at 1/500th if it can be taken at 1/50th without good reason, like when trying to throw a background out of focus. Even pictures of wildlife can be taken at this slow speed. Money spent on buying an inferior wide-aperture lens, where the object is to try to avoid using that aperture, would be better spent on a higher quality lens with a smaller maximum stop such as f5·6. Where it is possible to get away with a really slow speed we prefer to stop down to f16 or even f22 and, of course, use a steady tripod.

The adaptability of the 35mm camera is best exploited via a whole range of lenses. After obtaining a 300mm lens, one of

roughly half that focal length, say 135mm or 150mm, should be the next acquisition. This will enable subjects that do not run away, either because of their tameness or by utilising a hide of some description, to be photographed in close-up. Later the aim should be to get a longer lens, a 400mm or 500mm for stalking.

There is a tendency to think of wildlife photographers as intrepid travellers with huge lenses stuck on the front of tiny little cameras—they are not. Intrepid perhaps, but like every other photographer they obey one of the most fundamental rules of the art—they use the shortest focal length lens that they can at all times. While it may be necessary for the wildlife specialist to use telephoto lenses more than most other photographers, he does so simply because he cannot otherwise get close enough to his subject, or because his subject is so small that high magnification is essential to get any picture at all. As a result photographs of wildlife suffer from a narrow depth of field giving a characteristic lack of perspective and an unsightly blurred foreground. Such photographs also lack the fineness of resolution of the same quality shorter focal length lens. In many cases such characteristics are unavoidable, but the shorter the focal length lens the finer the end result. We cannot overstress this point particularly to the growing band of action shooters, who seem determined to use the largest possible lenses at all times.

Modern lenses are of two basic types—automatic and pre-set. The distinction is of crucial importance to the user of a single-lens-reflex camera. Automatic lenses allow the aperture required to be selected while keeping the lens open at its full aperture to facilitate composition and focusing through the lens. When the exposure is made the aperture automatically closes down to that selected. With a pre-set diaphragm the picture must be composed and focused at full aperture and the lens closed down manually only at the last moment before exposure. Stopping down to say f16 will not permit sufficient light to pass into the camera to allow accurate focusing. Automatic lenses are thus to be preferred but they are also considerably more expensive than the same size manual pre-set

lens. The ideal is an automatic lens that can be closed down manually to enable the photographer to check the depth of field. This is a particularly important requirement when working at very close range with a small subject, like a frog, to check whether everything is properly in focus. Several modern cameras have this refinement embodied in a depth of field button.

Apart from the automatic/pre-set distinction there are three categories of lenses suitable for wildlife photography: lenses that draw subjects long distances away to within photographic range; special focus lens systems like the tried and tested Novoflex; and lenses that permit a very close approach and magnify the original.

Big lenses, that is lenses larger than 300mm on a 35mm format, are of two basic types—the straight through 'normal' lens, and the reflex or mirror lens. The normal lens of say 500mm is in fact 500mm, or nearly 20 inches, from the front of the lens to the film in the camera. It is a heavy, unwieldy object. But with focal lengths of 1000mm, over three feet in length, the problems begin to get quite unmanageable and an assistant becomes progressively indispensable.

Mirror Lenses

Mirror lenses are designed on the same principle as the Newtonian reflecting telescope. On its way to the point of focus light passes into the lens, is reflected back on itself towards its source, and is then mirrored back once more to the film. The light passes along the same focal length, but a mirror lens can be physically as little as a third as long as a traditional lens of the same focal length making not only for greater compactness, lightness and ease of handling but also for steadiness. While hand-holding a 500mm normal lens poses severe problems, the balance and weight of a 500mm mirror lens is a surprise to everyone who tries one.

Wider possibilities of action shots are opened up by these lenses but one word of warning. The alignment of the mirrors is a delicate business and a single knock can ruin a lens

involving expensive expert repair. They must be carefully checked on purchase and at all times treated with respect. We found that we had to try seven different lenses before we found a 1000mm mirror lens that was perfectly aligned and capable of being accurately focused.

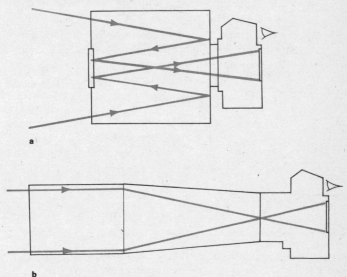

Figure 2. Difference in light paths between (a) mirror and (b) telephoto lens

Once found, however, we were staggered at the way the subject almost clicked in and out of focus. Due to the narrow depth of field an object is either sharply in focus or out of focus with virtually no graduations between. This means that an animal walking even quite slowly towards the camera is extremely difficult to keep in sharp focus and it is necessary to practise focusing ahead of the subject and allowing it to move into focus, releasing the shutter just a fraction of a second before it does so to allow for the slowness of the human eye, brain and fingers.

After a few years mirrors often become tarnished and fail to

give satisfactory results. There is thus, perhaps, a greater risk in buying a second-hand mirror lens than a normal one. For the same reason, mirror lenses should always be stored in a dry place. Cleaning a tarnished lens is a job for the manufacturer and an expensive one at that.

Mirror lenses have two disadvantages. The first and more serious is the fixed aperture—usually f5, f8 or f11. Thus 'stopping down' to the correct exposure involves using either faster shutter speeds, or light reducing (neutral density) filters. The other disadvantage is apparent in the results where high-lights on the finished print or transparency are frequently covered with tiny bright circles. This is not always unpleasant and some photographers actually like the effect, but we have seen pictures that are totally ruined by having a subject entirely surrounded by tiny light bubbles. Nevertheless the modern action photographer would be well advised to think about adding a 500mm or 1000mm mirror lens to his outfit as soon as he has mastered the art of working with telephoto lenses via his 300mm 'normal'.

Zoom Lenses

Many manufacturers have produced zoom lenses for the 35mm camera in recent years and the wildlife photographer would be foolish if he were not tempted. Zoom lenses have so many obvious advantages. Instead of the elaborate procedure of changing the lens for each different shot, the zoom lens enables close-ups and medium shots to be taken with the same lens. Popular zoom lenses vary the focal length from 35mm to 100mm, though there are longer and shorter focal lengths with larger ranges. Such a specification would make them ideal for our purposes but for one major drawback.

Normal lenses are calibrated for use at particular focal lengths whereas zoom lenses have to cope with the range that they offer. Inevitably the quality of definition suffers. Though the very best and most expensive zoom lenses are superior to cheap ordinary lenses at every focal length, they are not up to the standard offered by even medium-priced ordinary lenses.

For this reason we do not advise their use in spite of their obvious attractions.

Tele-converters

The same sort of arguments that apply to zoom lenses also apply to tele-converters. These fit between the camera and the lens and have the effect of increasing the magnifying power of the lens two or three times. As we have stated, lenses are computed in manufacture to perform a particular task. No matter how a well-made converter is used, there will inevitably be a significant loss of quality in performance. There is also a compensatory loss of one or two stops. Many photographers tend to ignore the fact that by adding a converter they are increasing the focal length of their lens twice or even three times. Thus a 150mm lens becomes a 300mm, or even a 450mm. Such focal lengths must be used, as far as is practicable, on a tripod whether they are normal, or 'created' by the addition of a tele-converter. Certainly we do not advise their use.

Special Lens Systems

Of the special focus lens systems the Novoflex is by far the best known and widely used. It is favoured by sports photographers, who, like wildlife specialists, cannot approach their subject too closely and who similarly need a really speedy system of focusing to catch the fleeting moment of action. The wildlife photographer uses the system for action shots of fighting and running mammals, blowing whales and flying birds. The system divides into two parts—a trigger hand grip that is spring loaded and squeezed into and released out of focus, plus a lens that screws into the front of the focusing device. The camera is mounted behind the trigger mechanism and there is a shoulder support and a whole range of different focal length lenses available. With the aid of a bellows a really effective system can be built up, but all the lenses are of the 'normal', i.e., non-mirror type and the larger units like the

640mm set-up are quite difficult to hold still without bracing in some way. There is, of course, no reason why the rapid focusing system should not be used on a tripod—we always use one if it is practical to do so. The smaller units are considerably easier to manage.

The old Contarex rapid focusing system is still also used though available now only second hand. It has one considerable advantage over the Novoflex system in not being spring loaded. Having focused on a subject it remains in focus until moved, without the photographer having to hold back a spring. A hand support beneath the front part of the lens is gripped with the fingers while the thumb rests on a gnarled pad (like the surface of a table-tennis bat) on the rear half. Focusing consists simply of closing the distance between thumb and fingers. A clutch is mounted on the side to increase or decrease resistance and this also enables the lens to be locked in focus. An integral part of the clutch is an over-ride that facilitates small adjustments in focus.

Equipment for close-up photography is dealt with later in this chapter under 'Bellows and Photo-macrography' but mention must be made of the special close-up lenses that are calibrated for high resolution at close range and that do not require extra adaptors in use. Most manufacturers of good quality cameras offer such a lens, though to take close-up pictures there is no absolute necessity to have one as there are several other methods that allow a close approach to the subject.

Viewing and Focusing

As we have seen, the SLR camera works with a mirror that flips out of the way as the exposure is made. The image is focused on a screen usually of ground glass but is, of course, reversed and at an angle of 90 degrees to the subject. This means that we have to look down into the top of the camera and that our natural reaction to move a subject to the centre of the frame will, via the mirror, move it farther out of view. This makes it very difficult to use the SLR with a waist-level viewfinder for action shots, quite apart from the fact that the

subject is difficult to find quickly at an angle of 90 degrees.

To overcome these problems a pentaprism is almost an essential. It turns the image back through a farther 90 degrees so that it can be viewed at eye-level in the same line as the subject, and reverses the mirror effect so that moving subjects can be easily followed. Many SLR cameras have a pentaprism built-in but others have interchangeable heads that allow the straight reflex viewing system to be replaced by a separate pentaprism. Though such a useful tool there are times, with insect photography for example, where pictures must be taken low down on the ground and where it is difficult to get an eye low enough to look through a pentaprism. In this case a straight reflex viewing system is best although some cameras have a special 90 degree finder that fits onto the pentaprism.

A range of interchangeable heads, i.e., the reflex, the pentaprism, the pentaprism with built-in light meter and a pentaprism giving a view at an angle of 45 degrees is very useful, but a straight pentaprism is best for the wildlife photographer.

No matter what viewing system is used the picture is focused on a screen. It is a disadvantage of many built-in pentaprisms that the screen cannot be changed, though both Olympus OM and Leicaflex allow focusing screens to be changed from within the camera itself. Nikon offer a range of 14 different screens each with its own characteristics and suitable for use with different lenses. Fresnel fields broken by a fine matt focusing spot give a 'ringed' appearance; plain matt with a split image range-finder are focused by bringing two halves of an image into line; but the ideal screen for both telephoto lenses and for close-up photography is plain ground glass.

Film and the Photographic Problem

The use of long lenses from 300mm to 1000mm or more creates problems that involve the very essence of the wildlife photographer's art. For many subjects telephoto lenses are essential and for action shots these lenses must be hand held. To stop the animal in its tracks a fast shutter speed must be used which will at the same time overcome the problem of

camera shake with hand-held shots. Unfortunately, two other conflicting requirements must be met. To ensure a sharp, well-focused result the photographer will want as large a depth of field as possible involving the use of a small aperture such as f11 or f16. And because he wants his results in the form of colour transparencies he will have to use a slow film of 25–100 ASA. As the slower films give a finer, less grainy result and far better tonal range he may well prefer to work with a slow 25 ASA film.

Thus all wildlife photography becomes a matter of compromise and all wildlife photographers constantly pray for really bright light without harsh sunlight. If a really fast colour film could be manufactured that would give the same results now obtained by 25 ASA film, the wildlife photographer would be the first to adopt it. Of course, even the most mobile of animals do stand still from time to time allowing the photographer a chance that he must be ever ready to take.

Perhaps a couple of examples will help make this complex of inter-relationships clearer. The scene is the Danube Delta. The photographer crouches in the bows of a rowing boat which is occupied by other naturalists who move and rock the boat from time to time. It is early morning and out of the rising sun pour cohorts of white pelicans. They sail by close overhead on still wings with occasional bouts of flapping that are taken up by each bird in turn down the line. Photography will be with a 300mm lens on the hand-held 35mm camera. The light is far from brilliant.

To stop hand and subject movement a 1/500th is used with a few shots at 1/250th on 25 ASA film. This means using the full f4·5 aperture of the lens with almost no depth of field. But pelicans are large birds and depth of field at 50–100 yards is comparatively good. The resulting transparencies are quite tolerable.

Contrast this with a lucky autumn day at a London reservoir. The photographer has come across an incredibly tame grey phalarope. Try as he may he cannot stop the movement of this hyper-active little bird while holding the lens steady, focusing and releasing the shutter. The bird is so tame that it comes

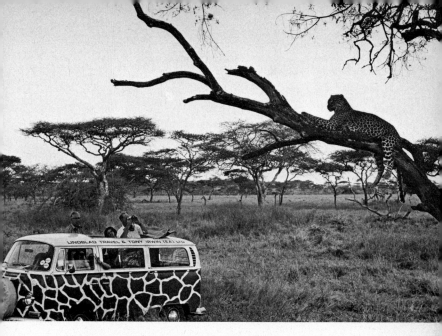

A safari party has the good fortune to come across a dozing leopard obliging enough to permit the photographer to change lenses. These photographs, taken from the same viewpoint, show the effectiveness of different focal lengths

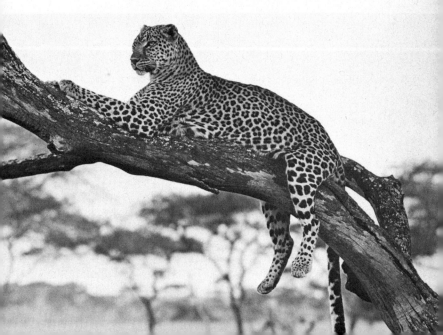

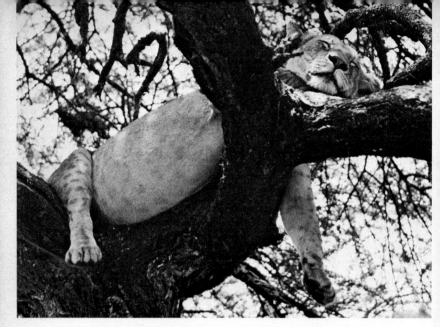

The bloated stomach of one of the well-known Lake Manyara tree-climbing lions is *some* indication that the animal will allow a close approach

The use of a bean bag provides an adequate support for even a long lens like the Zeiss 500mm mounted on the Hasselblad ELM through a car window *(David Hosking)*

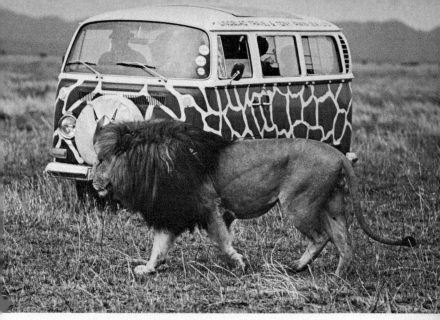

An adult male lion *(above)* walks nonchalantly between two safari minibuses. Although these animals seem so tame and confiding, it must never be forgotten that they are truly wild and potentially killers.

The approximate effect of different focal length lenses can be read off from this photograph of African elephants at a waterhole.

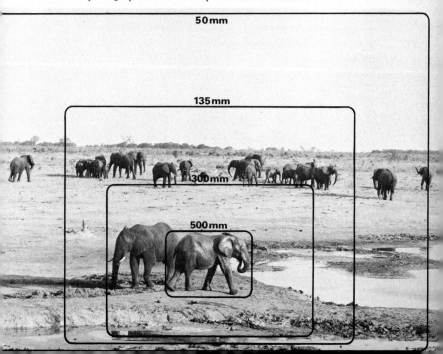

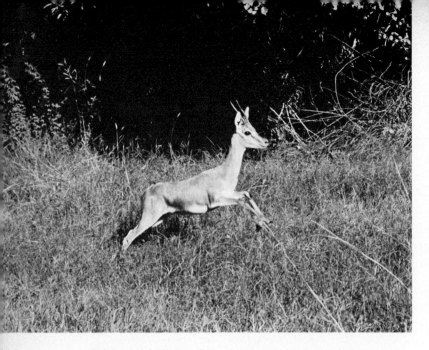

Chinkara, the Asiatic gazelle, photographed in Pakistan. These timid
little creatures must be 'shot' on sight – they will allow no stalking

The black rhinoceros of Africa, in contrast, is both tame and
approachable – here the danger is of provoking a charge

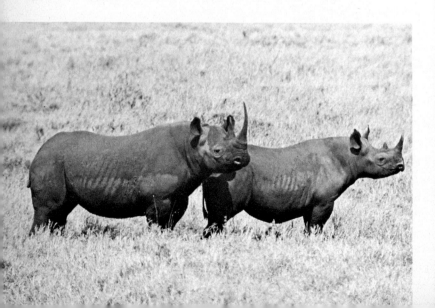

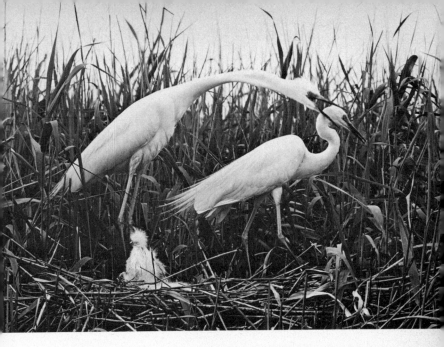

Great white egrets at their nest showing the plumes or 'aigrettes' for which they were shot to the point of extinction. At the insistence of the local guide-warden, the hide was quite unnecessarily camouflaged with reeds.

Permanent viewing hides, such as this one at the Royal Society for the Protection of Birds' Reserve at Minsmere, Suffolk, provide ideal opportunities for the bird-photographer to 'wait and see'.

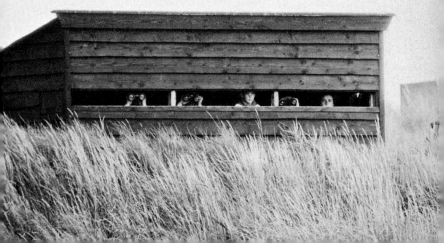

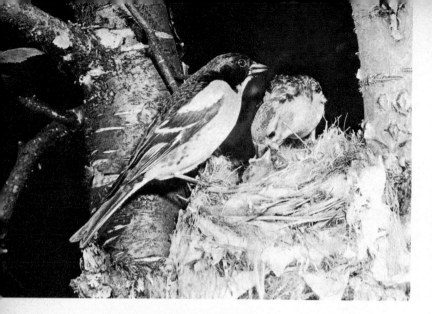

A pair of bramblings at their Scandinavian nest in the crotch of a birch. The small pylon hide was constructed of well-guyed alloy dexion. Two separate flash heads *(a)* were used, mounted on twelve-foot high extendable tripods; *(b)* disposable 510 volt battery packs; *(c)* nest site. Note the tautness of the canvas to avoid flapping.

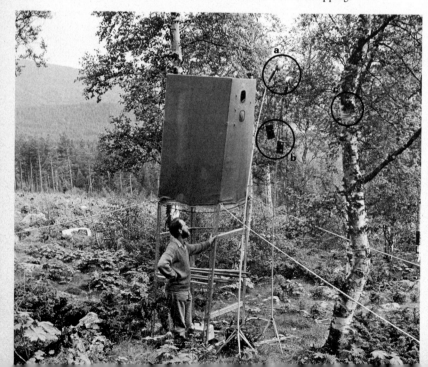

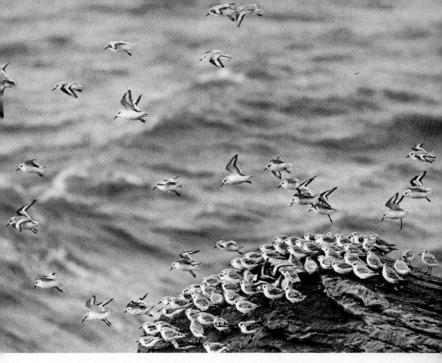

Two shots of sanderling taken by different 'wait and see' techniques. From a hide at the high-tide roost at Hilbre Island, Cheshire *(above)*; and from a hide at feeding grounds at Minsmere Reserve, Suffolk *(below)*

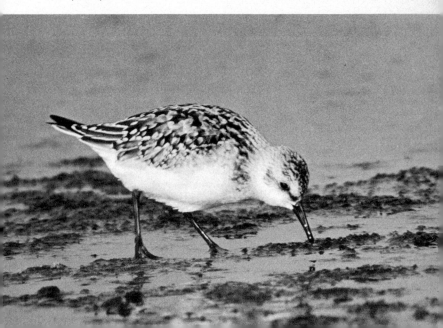

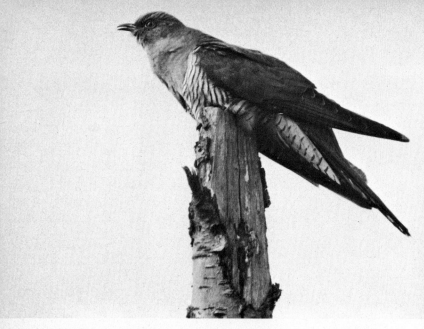

Baiting will attract a variety of birds and some mammals. The cuckoo
(above) was attracted by playing a cuckoo tape-recording. The blue
and great tits *(below)* are squabbling over fat and sunflower seeds
lodged in a post

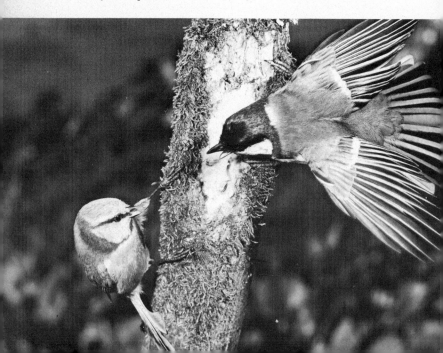

closer than the lens will focus (within 15 feet) and at close-range with extension tubes the resulting depth of field is totally inadequate to deal with the subject.

If the reader is now confused we have at least got over the point that what at first appeared to be a simple aim-focus-take process is patently more complex.

Startlingly enough, by using a camera fixed firmly on a tripod and waiting until their subject was absolutely still, many of the early wildlife photographers managed to get away with exposures of up to $\frac{1}{2}$ sec. and utilise a small aperture even with a small active bird. This, of course, gave them great depth of field and the avoidance of blurred foregrounds, but also facilitated the use of fine resolution materials instead of very grainy ones.

These long exposures were made possibly by highly controlled conditions that are just not necessary today. Action shooting is not only extremely popular but is also adding significantly to our knowledge of how animals behave. Film gives us the opportunity to record and subsequently repeat a piece of behaviour over and over again, thus multiplying the chances of our understanding it. But action shooting demands high speeds capable of freezing movement. A 1/250th is quite adequate for most animals and will even freeze a bird as it flies toward the camera. But for a bird flying across the camera a 1/1000th is necessary and in the case of a fast moving bird like a swift even a 1/2000th is unlikely to stop all movement. As to stopping the wing-beats of small birds like chats or warblers, not to mention hummingbirds, the techniques required take us right outside the realm of this chapter into the world of high-speed flash.

The trouble here really centres around the slowness of colour film. In black and white we can happily use 400 ASA stock but in colour, particularly 35mm, we like to use 25 ASA, where one is lucky to get away with 1/125th at f8 even on a normal sunny day.

Most animals 'freeze' from time to time and this gives the patient photographer a chance to snap a few frozen 'action' shots. Unfortunately in the case of gazelles jumping, and

whales blowing, the frozen action point just does not exist.

Before the war the most commonly used negatives for wild-life were quarter plate film packs with 12 exposures in each, and glass plates. If a good result was obtained 1 in 12 times the photographer would be well satisfied to throw 11 in the waste paper basket. M. D. England, the bird photographer, once said that what he liked about doing his own developing in the field-camp at night was that he could throw all of his results away instantly. Today there is a tendency for photographers to expect 36 good shots from every film and so they bang away at high speeds. In contrast the purist has kept his average roughly constant and expects two or three really outstanding shots out of a reel. But to get these high quality results he must use a slow shutter speed and a tripod, and thus the majority of shots will show movement and will be no good at all.

Perhaps at the end of this the reader who has borne with us will say:

"I've got it. What I need is a 2000 ASA film and then I can hold the camera in my hand, shake it all over the place, use a big lens at f.22 and at 1/2000th and it will all be marvellous". Well, frankly it won't. Such fast films exist in black and white but give very ghastly grainy results.

Many of today's pictures are grainy and for some people this graininess is very attractive. Some also like pictures to be blurred to give an impression of movement and action. Certainly blurred wing-tips on a flying bird do help to create this impression but total, if recognisable, blurs must not be excused on artistic grounds. Photography is like any other art form, the student must go through the mill learning all the traditional techniques and skills and form a true appreciation of their worth before hiving off on his own to experiment with movement, colour effects, bleach outs or what have you.

Camera Supports

If the camera can be supported in any way whatsoever, a better picture will result. The value in using a tripod cannot be over-stressed and yet there is a feeling current among wildlife

photographers that a 35mm camera with a 300mm lens is just as effective without one. Camera shake is admittedly just one cause of poor pictures, but a cause that can frequently be eliminated. In reality it is possible to use a 300mm lens without a tripod but this does not mean that it is advisable. For taking views and habitat shots with the 50mm lens, hand holding is quite adequate, but with any telephoto lens a tripod should be used wherever possible. Des and Jen Bartlett and Alan and Joan Root are fully fledged, highly successful, professionals and they hardly ever take a still photograph using a telephoto lens without a tripod. Yet amateurs frequently seem to think that they know better.

Tripods should have a pan and tilt head, some means of levelling, ideally a built-in spirit level, and should be as heavy as one can transport and carry. There is little point in mounting a huge lens on a tiny little lightweight tripod from your corner photographic shop. Even the movement of the camera mirror is often quite sufficient to set everything vibrating. The huge professional tripods with hydraulic reservoirs to avoid jerky movements when panning and with spikes at the feet to push firmly into the ground are ideal. Always work on as heavy a tripod as possible. One that we have in constant use weighs twenty pounds.

Having set the camera on a tripod it is a pity not to use a cable release thus avoiding any chance of shake while making the exposure. For preference use a cable release that connects to the tripod pan handle and enables pictures to be taken by ordinary two armed people. Separate cable releases call for three-armed men, one for focusing, one for directing and one to release the shutter. If your existing tripod does not boast a special cable release mechanism the use of a piece of tape to connect up to the pan handle is a very simple remedy. The mirrors of some single lens reflex cameras flip up at the moment of exposure with such a jolt that the whole outfit shudders. In these circumstances we have found that pressing our head against the camera helps to hold it still.

If a tripod is impossible for the type of photography envisaged there are excellent shoulder supports with built-in

cable releases that cut down camera shake considerably. A
good support is one that is adjustable in length and height so
that anyone can find a comfortable fit. The essence of this
method is to eliminate shake by relaxing. Using such supports
for wildlife photography with big lenses is very much like
hunting with a rifle. One must stand firmly, left foot in front
of the right and to one side, lean against a tree or wall or better
still lay down and rest the elbows on the ground. Even mount-
ing a camera on a shoulder support acts as a constant reminder
of the existence of shake and as a prod to avoid it.

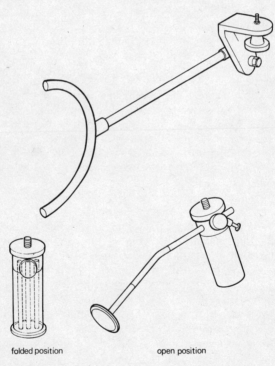

folded position open position

*Figure 3. Two types of shoulder support among the many, old and new,
on the market.*

Cars not only make excellent wildlife photographic hides but also act as effective supports. Car windows can be wound up and down to comfortable heights and we know of a couple of photographers who have made special clamp-platforms that fit to their car doors for poking large lenses out of the windows. It is a good idea to slide a ring of rubber around the lens to avoid scratching which will damage the lens finish and perhaps disturb the subject. A sand or bean bag placed on the roof or bonnet of a car and moulded to the shape of the lens makes a very good support. Failing this a folded pullover or jacket is a second best. Even a 600mm lens can be used by wedging oneself and the lens into the corner of a car—but for goodness sake get the driver to turn off the engine and prevent the lens from vibrating. When working with other photographers from the same car we always make a point of whispering 'shooting' to warn the others not to move at the critical moment.

The human ability to stand firmly obviously varies but we know of two stalker photographers, Brian and Sheila Bottomley, who can hand-hold a 1000mm lens and get first class results with a special technique of their own. What they do is to raise the camera and focus on the subject. They then lower the camera and relax for a few seconds before bringing it up and firing straight away before they have time to develop shake.

Bellows and Photo-macrography

Even with large lenses some natural history subjects still fill only a tiny part of the frame. Birds like sparrows, and amphibians such as toads are tiny blips on the screen even when a 300mm lens is focused down to its limit at say 15–20 feet. Whereas one can easily catch and control a toad and still turn out a natural looking picture, to do so with a sparrow is quite a different matter. Toads can be approached closely without alarming them, but most sparrows and other birds will fly away at the sight of a photographer at three feet with a standard 50mm lens. In these circumstances small birds can be photographed with long focus lenses by using a bellows or a set of

extension rings. Fitted between camera and lens they enable a subject to be more closely approached and focused on than with the lens alone.

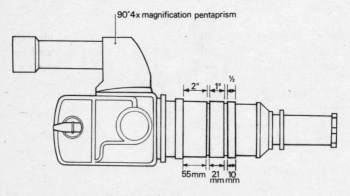

Figure 4. Hasselblad with pentaprism and three extension tubes (non-metric measures are approximate)

A bellows has the advantage of flexibility, it being easy to change the distance between the lens and the film simply by turning a knob. Extension rings, on the other hand, are of fixed lengths and must be separated to change distances—not a process to be advised while keeping a small bird waiting to have its portrait taken. If you choose extension rings ensure that they have a clutch that enables the lens and camera to be lined-up correctly after the rings have been screwed home, otherwise you may end up with your camera at an angle when the lens boss is mounted on a tripod. One or other of these devices must be included in every wildlife photographer's equipment, but remember that in using bellows or extension tubes with many cameras you cut out the automatic diaphragm. And that with others a double cable release is necessary—one to stop down the lens, the other to fire the shutter.

Close-up or photo-macrography (we shall not deal with photo-micrography in this book) is an extension of the basic principles of wildlife photography. The subject matter consists of small animals and plants, and equipment must be designed

to allow a very close approach. Most photo-macrographers use a standard lens of some 50mm focal length though there are lenses, often prefaced by 'micro' in their name, that are specifically designed for close-up work. They are usually about the same focal length as the standard lens but focus down to within two or three inches of the subject.

If you do not want a specific close-up lens, or you want to get even closer than this will allow, there are two distinct methods that can be adopted. Magnification can be increased by attaching a supplementary or proxar filter to the front of the standard lens. This is the easiest and cheapest method, and there are usually several different magnifications available enabling a progressively closer approach to the subject. Though cheap they are effective and have the great advantage of allowing the automatic diaphragm of the taking lens to function normally. But do be sure to obtain supplementary lenses of good quality; the lowest priced ones simply ruin definition.

The alternative to increased magnification is to extend the lens to film distance by inserting extension tubes or a bellows. This facilitates an even closer approach and a larger image on the film than is possible with extra magnification. Some outfits have a special adapter ring that allows the lens to be attached in a reverse position and give optimum performance at ratios greater than 1:1. It should be remembered that the closer the lens to the subject the narrower the depth of field. It is, therefore, necessary to stop the lens down to a small aperture to get everything in focus. As stopping-down requires a strong light source it is not surprising that most of these small subjects are usually photographed by flash.

Filters

Filters are a complex subject worthy of a chapter on their own, but by confining our attention largely to colour work we cut down the subject to manageable proportions.

A UV (ultra-violet) filter is almost essential. It fits on the camera lens and apart from protecting the lens against dirt and

damage—and remember that it is far cheaper to replace a filter than a lens—eliminates excess ultra violet rays. Colour film is carefully balanced for use in mid-day sun, at inland sea-level sites and at other times and places, light will affect film differently. Mountains and the sea shore are the two classic examples that give transparencies an excess of blue that can be reduced by the use of a UV, haze or sky filter as it is often called. As there is no compensation of exposure required many photographers leave their haze filter permanently on the lens.

Exposure Meters

The right exposure meter is a wonderful slave but a very bad master. Many photographers feel that with a light meter built into the camera all they have to do is centre the needle and fire away, forgetting that over-exposure through reflected light is so common, and ruins so many good pictures. No matter how good the exposure meter there are several rules that should guide its use. With snow scenes of subjects like ibex running across a glacier, always stop down an extra stop, intentionally under-exposing on the reading given by the meter, otherwise the snow will look like a white sheet with no detail. With very dark subjects, such as a woodcock on its nest in dense woodland, you need to use one stop larger than indicated to get more detail into the plumage.

Built-in selenium cell exposure meters tend to fatigue after some years, and it is advisable to check them at intervals. Batteries in photo-electric models should be tested regularly.

Needles can stick and mechanisms can fail, and there is nothing more soul-destroying than arriving home after an exciting photographic safari to find that all of the results are drastically over or under exposed. The best check is a professional one by a camera technician, but in the field a simple check against a companion's meter will be adequate, though you might think that it is his meter rather than yours that is wrong. In this case, as well as in the absence of another meter, a check against the manufacturers' guide table contained in every pack of film is perfectly adequate. In fact there are some

professionals who still rely on this method and never use light meters at all.

Today's photo-electric cell meters are excellent and the tiny batteries that power them can last up to two years. They may, however, be left switched on accidentally and for this reason, if no other, it is wise to take spare batteries on a trip.

Modern, through-the-lens (TTL) meter systems have so many advantages over the older coupled meters that there is little point in going into them. One of the less obvious, but of particular interest to the wildlife specialist, is that meter readings can be taken from inside a hide without disturbing the bird or mammal which is being worked. Unfortunately most, if not all, $2\frac{1}{4}''$ square cameras lack TTL. Hasselblad have recently produced a pentaprism which incorporates one but even so it is not automatic. In any case a separate meter is always worth having as a reserve and for circumstances in which the light can be measured beforehand, but most lions do not take kindly to a series of close-up readings.

As authors of many books we receive a considerable amount of correspondence—doubtless this book will provoke more. Many letters simply require information that is already given in the books themselves and some are simply spurious. Both of us are extremely busy people, but we do not mind answering serious inquiries with which we are specifically qualified to help. A stamped addressed envelope or International Reply coupon would be a courteous and appreciated gesture.

2 Safari Photography

When the whole object of an expedition or safari is to obtain photographs it seems somewhat superfluous to ask 'Why take pictures?' Yet the self-analysis that we have advised in almost every section of this book is appropriate here too. What are the results for? The answer to this and other similar questions will determine not only the equipment but also the approach to the task.

If you want to show the products of your safari to your friends, or give a lecture, then you must attempt to obtain a balanced cross section of the trip. Your audience will want to know what the country is like and its variety of landforms. They will want to see how you got there and how you travelled. Quite recently we were asked after a lecture why we had not shown any pictures of petrol stations, and whether such stations were few and far between in the country concerned. Though perhaps a bit surprising, the question did show the sort of detail that needs to come across in a slide show and the attention to every aspect of living that makes a thorough and definitive talk. You may start with scenes of preparation and end with a sunset but what really counts is the scope and quality of the pictures between. Three or four pictures of elephants may be exciting but fifty are guaranteed to send any audience into a state of stupor.

If you want to sell your photographs do not go to East Africa. Almost everything in this wonderful area has been photographed *ad nauseum*, and there are several excellent wildlife photographers who are resident there and who stand a far better chance than you of obtaining the outstanding shot. Go to East Africa simply because it is there and everyone ought to see it. If selling is your aim, choose an area that is under-

worked like South-east Asia or South America. The subjects may be more difficult, but at least you are in with a chance.

Preparations

For most of us a photographic safari is a once and for all chance, an opportunity that must be taken while it is available for we will probably never get another. For this reason, if for no other, we should ensure that we set out fully equipped and thoroughly prepared. Imagine the frustration of not having the most suitable lens for the subject, or missing a superb action shot because you were not fully conversant with the workings of your camera. We know of photographers who have run out of film on safari and only been able to obtain inferior stock locally at excessive cost. When you have carefully worked out how much film to take with you—buy double that amount. When planning your safari you can have no idea of the abundance of subjects that will present themselves. Prepared is forearmed, and it is a general principle to take too much equipment rather than too little even if this does mean paying the exorbitant rates that airlines charge for excess baggage. Our friend Roger Tory Peterson once crossed the Atlantic with so much gear that the bill for excess baggage was more than the cost of his ticket.

If being well equipped is sensible, being untrained and unfamiliar with either the equipment or with wildlife photography is simply foolish. It seems such a pity to make a start at photographing animals in the East African game parks. A little practice on deer in a park before you leave will not only show you what you are doing wrong, but may well teach you a lesson in what even tame animals will allow. It seems preferable to us to have a scare from a red deer stag than a mauling from a lion or leopard.

Though safaris are expensive they are not absolutely beyond the reach of anyone. Packaged tours are now organised to almost every part of the world from Antarctica to the Soviet Union. The price for a fortnight in the East African game parks has fallen dramatically over the past few years, and can be

enjoyed for about the same price as a medium cost camera and telephoto lens. Of course, such safaris are not necessarily perfect. They may include only a basic hotel with day expeditions into the surrounding countryside when the knowledgeable naturalist would like to go farther afield. It certainly seems a pity to go so far and yet not work the area thoroughly. Though more expensive, there are a host of small operators organising tailored safaris for individuals and small groups who want to see and photograph a bit more than the run of the mill tourist. Nevertheless the mass tour operators offer a fine bargain to anyone who simply wants to go 'on safari'.

East Africa is so marvellous for animals that it is not surprising that 'safari' has virtually become synonomous with a trip to the game parks of Kenya or Tanzania. For this reason we shall devote considerable space in this chapter to African safaris.

Expeditions

The line between safari photography and expedition photography is a fine one, and tour operators use terms like 'photographic safari' and 'wildlife expedition' almost interchangeably. Perhaps the terms that we use do not matter too much though our approach to photography will be determined by the seriousness and purpose of our visit.

'Expedition' smacks of scientific overtones and is a serious undertaking in which the photographer is allotted certain specific tasks. Though he will doubtless still enjoy himself, his attitude will be essentially a professional one, recording not only the more startling and attractive subjects but also the preparations, transport and day-to-day activities of the expedition, as well as documenting the smaller, less obvious ecological and micro-fauna and flora of the area. As part of his work he may well have to put aside some wonderful opportunities for photography in the pursuit of a comparative obscurity, and on occasion carry out a photographic task that he does not find particularly appealing.

In our opinion no expedition should set out without a professional photographer. As a professional he will think in photographic terms in a way that an amateur will not. On one of the famous 'Mountfort' expeditions to Pakistan we were unfortunate enough to ·crash one of our vehicles off a narrow jungle path. Naturally enough our first reactions were for the safety of the passengers, and all hands immediately set to extricating them, shouting orders and advice and generally behaving normally in the circumstances. Some time, and twenty or so miles later, Guy Mountfort turned to Eric and said:

"You know, we really should have taken photographs of that crash", to which Eric was able to reply that he had shot off a whole roll. In fact, of course, it was second nature to do so as it would have been to any professional in the same circumstances. Only the professional thinks constantly in photographic terms, and it is simply not enough to appoint an ordinary member of an expedition's scientific staff as 'photographer' simply because he has a camera. He will probably not think of using his camera until his own research is finished, by which time most of the best chances of photography will have passed. Altogether too many expeditions return home with inadequate photographic coverage.

Where to go

Though a huge percentage of safari photographers visit East Africa they do not all do the necessary homework as thoroughly as they should. East Africa is a huge area and many of the species of mammals and birds are highly localised. In the same way as the black grouse is not found throughout Britain so, too, is the klipspringer not widespread in Kenya. For flamingoes the photographer goes to Lake Nakuru, for crocodiles he goes north to the River Nile near Murchison Falls and for lammergeier to Hell's Gate. It is not within our scope to provide a guide to where to photograph what but John Williams' *A Field Guide to the National Parks of East Africa* is published in the excellent Collins Field Guide series. Where to

go depends on what purposes you have in mind and on thorough research before you set out.

East Africa has no monopoly on game parks and nature reserves. The British photographer could enjoy a safari in the wildfowl refuges that are strung out along the east coast of North America. The American photographer similarly would enjoy the Coto Doñana in Spain, and the Camargue in France. India's wildlife is fast declining but there are reserves that are truly wonderful to visit, that hold tigers and deer, as well as some marvellous wetland sites for birds like the marshes at Bharatpur. In Europe the Vanoise and Gran Paradiso National Parks in France and Italy provide opportunities to photograph ibex and chamois, in Australia the Kosciusko State Park offers duck-billed platypus and echidna, while Los Glacianes National Park in Argentina boasts puma, guanaco and condor. The opportunities are vast and no matter what his aims the well-prepared photographer will find safari photography a considerable challenge and a great thrill.

Choice of Equipment

The advice given in Chapter 1 on Cameras and Equipment should be read thoroughly by anyone planning a photographic safari. The only additional factor that is distinctly safari in type is the problem of weight. Though, as we have said, if there is any doubt about the value of a particular item it should be taken. Nevertheless weight should be kept to a minimum. Decisions must be taken and choices made. The simpler the equipment the easier it is to be ready to take opportunities presented. A pride of lions basking in the sun may well allow lenses to be changed, a motor drive to be attached and so on, but a herd of ibex dashing off across a snowfield must be 'shot' in an instant, or lost forever.

For most safari photography the 35mm SLR camera with a 250mm or 300mm lens is a good standard. Mounted on a shoulder support it is ready for instant action. Occasions will arise when a closer approach is possible and for this we prefer to use the 135mm lens, while other shots may require the use

of the longer 400mm or 500mm lens. The $2\frac{1}{4}''$ square format is bulkier and slightly more awkward to handle, but many photographers find the larger negative or transparency worth the slight sacrifice in freedom of action. With this format the 250mm lens is a good standard, with the 150mm and 500mm lenses for closer and more distant subjects respectively.

The standard 50mm lens (80mm on the $2\frac{1}{4}''$ square) is an essential for scenics and habitat shots, as well as with the extraordinarily tame subjects that will be found from time to time. But always remember that large wild animals can be dangerous no matter how 'friendly' and tame they may appear. Keeping a 'safe' distance is always advisable and never forget that, although it often seems so, you are not photographing in a zoo.

All too often on safari the lesser game, the smaller mammals, reptiles, amphibians, as well as bats and smaller birds, are neglected or ignored. The serious photographer will want to record these, as well as the flora, and may well find that close-up equipment in the form of extension tubes, bellows or proxar attachment is required. To obtain the depth of field required a flash unit is always worth having at hand. Though nocturnal outings are not allowed in most East African Game Parks except in special circumstances, this ruling does not necessarily apply elsewhere. Many mammals are nocturnal and if the opportunity for photography presents itself it would seem a pity not to be able to take it for the need of a flash unit.

Transporting Equipment

Equipped then with camera, a range of lenses, a shoulder support, close-up accessories, a small flash unit and light meter, the safari photographer is ready for the fray. Carrying equipment is always something of a problem. While we use metal carrying cases for transporting gear we prefer not to take these in the field. The basic camera and lens can be hung round the neck and we know of one photographer who regularly sports a trio of Hasselblads about his person. We like to carry alternative lenses and other equipment in a rucksack within which each

item is protected by its own thick canvas draw-string bag. Inside the rucksack certain items are always kept in particular pockets to facilitate finding them quickly and for ease of checking.

We are thus ready for instant shooting while remaining flexibly equipped and highly mobile. Film should always be kept as cool as possible and, while we like to have a large quantity at hand, there is no need to take the entire safari stock on every trip. Four or five rolls of 35mm can be scattered through pockets and another four lodged in the coolest place in the car. The rest can be left in the hotel room or even in the refrigerator if the chef is understanding. Though it is advisable to store film in the cold, it is bad to keep putting it in and taking it out.

Choice of Film

We prefer to use the slower colour stock wherever possible, but even in the dazzling sunlight of the tropics a 25 ASA film allows little flexibility. Most animals, including the photographer, become very lethargic in the heat of the early afternoon sun. Sleeping subjects do not usually make for exciting shots, and bright sunlight creates harsh and unsightly shadows. It is better to give up the idea of mid-day photography altogether and concentrate attention and energy on the morning and early evening periods, when subjects are more active and easier to find. Unfortunately this often means that lighting is not as brilliant as we would wish. Add this to the need to stop movement in the subject and the shake of the hand-held camera with telephoto lens, and it can be seen that a faster film has its place. Of course, some photographers will wish to work with black and white as well as two speeds of colour. Thus the perfectly equipped photographer will have three camera bodies, a single body with three interchangeable backs, or a mixture according to the circumstances. It is only on very rare occasions that we have fewer than two cameras round our necks.

Unfortunately most 'commercial' safaris make a late start

after a leisurely breakfast which puts paid to early morning shots. They also return for afternoon tea and you can say goodbye to giraffes against the setting sun.

Forewarned is Forearmed

There is certainly a good reason for taking two camera bodies as an insurance against accidental damage or a fault developing in one of them. Skilled photographic technicians are unlikely to be very numerous, if they exist at all, in remote parts of the world, and while running out of film seems foolish, losing the use of the only camera seems the height of folly. Two cameras can, of course, be used concurrently with different film stock, but if one becomes faulty photography can at least continue. In the same way small items like filters, batteries for light meters and other odds and ends should be duplicated.

Most photographers take active steps to reduce all risks to a minimum. They ensure that their cameras and equipment are tested well before they depart. They check the servicing by putting a couple of films through the camera before they leave to ensure that the technicians have done their job properly. On arrival on safari they shoot off a film that can be locally and quickly processed—not a film that has to be returned to the manufacturer for processing. In this way they can check that light meters are functioning properly and that the sometimes unbelievable readings are, in fact, true.

Shooting on Safari

Most safaris are vehicle-based and those in East Africa are so of necessity. It is illegal to step outside the car in most parks except in hotel or village compounds. Cars are, however, excellent hides and most animals have come to accept them as just another part of the scenery. Unless the safari hires or purchases its own vehicle, the minibus is the most likely form of transport with a local driver-guide who is expert at his job. Some of these chaps have worked on safaris for so long that they know exactly what the visitor wants to photograph, where

to find the best subjects and from what angle he will want to shoot. They also know just how far they can push a subject in their efforts to get you close enough to shoot, without endangering the van and its contents (i.e. you), or scaring the subject away. The driver also knows the rules and regulations that govern visits to the park, and wants you to leave him at the end of the trip completely satisfied and in a generous mood.

It will, of course, become apparent over a few days what the party wants, and here we hit one of the major snags of the mass package-deal safaris. Some members of the party will, like yourself, want to spend long hours in the field photographing wildlife all day long. Others will be content with the brief middle of the day session and a few snaps with an Instamatic. Most members of a party fall between these two extremes which can be frustrating for the enthusiast and tiring for those who prefer a more leisurely approach. If the party is large enough the better tour operators will divide members up into car loads sharing a common approach. Groups quickly become established and can, of course, ask to share a vehicle.

Best of all is to organise a safari of your own with friends known to share your enthusiasm. Cheap packages can be arranged for any number, and writing to a few operators on the spot will soon settle travel and transport arrangements and price. Most firms are prepared to offer substantial discounts to parties of eight or more, and such arrangements have the advantage of allowing you to be with your friends as well as reconciling possible conflicts of interest.

In the field, the search for quarry may be of two types: the search for a particular animal or the seeking out of any photographic subject. On most safaris the members will call a halt at the first animal that is seen, but gradually over the days they become more discriminating and stop only for these two reasons.

Once he knows what you want the driver will be invaluable in obtaining the right opportunities. He will approach timid subjects upwind and wait in the right spots for them to come unconcernedly towards you. He will get the light behind you or, if you prefer, in front of you so that you can shoot into it.

One friend of ours teamed up with another photographer on the spot to share a car because, while he preferred the light over his shoulder, his new found friend preferred shooting directly into it. With two sides to a car they formed an ideal team.

Background Research

Some subjects simply present themselves for photography while others require great field skill and knowledge. If you want shots of a bull elephant at bay with its trunk raised and ears cocked, do not take your friends—go solo with a really first-rate guide. Though highly dramatic such subjects are extremely dangerous and no tour operator would, or should, dare to endanger the lives of a party in this way. Similarly young elephants with their mothers usually keep to the middle of the herd for protection and are exceedingly tricky to photograph. A pride of lions asleep is a common enough East African sight, whereas the same group disputing a kill provides more opportunities for photography and is a more elusive phenomenon.

The most successful photographers have a thorough knowledge of wildlife and a sufficient background in their subject to know what they want. They will know that carmine bee-eaters frequently perch on mammals as well as other birds like kori bustards to feed, swooping off to pick up insects disturbed by their host. They know that oxpeckers feed on many large mammals other than oxen, and that there are two distinct species to be photographed. They will know that Lake Nakuru is for millions of flamingoes but that Naivasha has a far larger variety of birds. In safari photography, as with other wildlife work, knowledge is the key.

Given the same degree of knowledge of the subject and well chosen equipment, the skilled photographer will obtain better shots than the unskilled. His 35mm SLR camera with 300mm lens mounted on a shoulder support will be ever ready. He will have a plentiful supply of film distributed about his pockets. He will have taken light readings so that he is ready to shoot as soon as the vehicle's engine is turned off. But he

will also take care with composition and be ready to change his lens quickly and efficiently. He will take the trouble to get a fresh light reading should conditions change, though generally 1/125th at f8 with a 25 ASA film will be appropriate throughout the day. He will wait for a walking subject to stop as it will eventually. He will want shots of the animal feeding, shots with its head up and alert, of groups as well as individuals on their own. We have found, for instance, that it is extremely tricky to obtain photographs of a single flamingo at sites where they gather by the million.

Technique and Skill

The best portraits show the subject against an attractive background, even if the photographer has to wait for it to move into place. The subject must then adopt a pleasant pose— again a matter of waiting—and the viewfinder must not be cluttered with other animals. Most safari mammals have four legs but we have seen many photographs of six-legged and even eight-legged animals created by one beast standing behind another. This careful, creative approach can be contrasted with the simpler see-shoot-move-on of the mass of safari tourists who inevitably end up with decent if unpleasing and boring shots.

This does not, we would stress, mean hesitating when an opportunity presents itself. Film is expendable and the golden rule is shoot first think afterwards. Many photographers confronted with an exceptional opportunity have run through a complete film only to find later that the subject is tame and approachable giving them time to think, compose, experiment with a range of apertures and shutter speeds, and carefully choose the best background. Nevertheless the earlier shots are seldom wasted, particularly if the subject proves less tractable.

The viewpoint is often fixed for you on safari, but while most photographers will have their head in the sky poking out of the roof of the mini-bus the lower windows are often neglected. The lower angles can give the chance of a more dramatic shot and the thoughtful photographer will always

have in mind that he can drop down three or four feet for effect. A bull elephant photographed from a low viewpoint looks even bigger and more dramatic than one portrayed from a height of seven or eight feet. He will understand that close-ups of the heads of mammals are also dramatic, often more so than the whole body and that given a static but appealing subject he can change lenses to obtain different effects.

Horizons are a frequent cause of trouble to the cinémato-grapher but must not be ignored by the still specialist. There is very little that one can do about a misaligned horizon with a colour transparency and the problem should not be over-looked no matter how exciting the subject.

Safari Action

Often the safari photographer will want something more than a portrait. He will want action or drama and this in turn will affect the way he works. Many of the smaller gazelles frequently jump, and though we have seen photographs published that were obviously set up with barriers to force the cornered (or captured) mammal to perform, there is no reason why running and jumping shots should not be obtained wild and free.

While other members of the party are shooting at 1/125th sec at f8 or f11 the action-man will be waiting with camera settings of 1/500th at f4 or f5·6. He must be ever ready to shoot at a moment's notice. He would, of course, probably choose a faster film enabling him to set his camera at 1/1000th at f11 or even f16 to facilitate focusing and he must be prepared to throw away many of his results. In fact he may have a separate camera and lens always at the ready for just such occasions. But one superb result in a spool of 36 exposures is better than 36 indifferent lifeless ones.

While the action-man is bound to use a shoulder support most occupants of the vehicle can take advantage of other methods to keep their equipment steady. It is often not possible to use a tripod, though we have used one on the back of a land-rover. But we always take a few canvas or thick polythene bags with us that can be filled with sand on site and which, when

rested on the roof of a minibus, form a perfect support for the lens. They are as steady as a tripod and additionally protect the lens from being scratched on the metal of the van.

If it appears that there is more to safari photography than long-focus lenses and getting to the right place, then we have come some way towards success. The major problem is one of composition. Treat the animal as part of the scenery, and the scenery as complementary to the subject. Though we have seen hundreds of shots of animals against a backdrop of Kilimanjaro, it does make a nice picture. Above everything else familiarity with the camera is crucial. Taking pictures should be automatic not a matter of 'What do I do next?'

Post-exposure

It is very easy to sink into a comfortable armchair at a safari lodge after a hard day's work in the field and re-live the excitements of the hunt with good companions. A few pre-dinner drinks will inevitably lead to a late night and you will feel tired and jaded the following day. Far more important is the care of your equipment. Immediately after exposing a film, re-package it in the container and store it away in your photographic bag so that only unexposed film remains in your pockets. Always change films in the shade, even if it is only the shade of your own body. Having got back to base, store the film in the driest, coolest place you can find and always well away from air-conditioning units. These units are a common cause of condensation on optics. Dampness inside the camera, which rusts the shutter and other metal parts, may make the film stick and ruin it completely.

Dust and dirt are the constant bane of a safari photographer's life and no matter what else you do, a thorough cleaning job on all items of equipment is essential every night. Our usual practice is to perform this task as soon as we have cleaned ourselves so that we can relax and enjoy company after dinner.

A soft photographic brush is used to clean the inside and outside of the camera and the lenses themselves. Filters must

be removed and cleaned and polythene storage bags must be replaced regularly. A single speck of grit in the camera can cause travel marks (tramlines) on the film and completely ruin a whole day's shooting. In safari photography cleanliness is even nearer godliness than usual.

3 Bird Photography

Though photographs of birds had been taken earlier, it was the work of Richard and Cherry Kearton in the early part of this century that established the foundations of bird photography. With their heavy and awkward field cameras, the requisite heavy-duty tripod and the necessity for long exposures, they recognised that there was little chance of their going to the bird and so they began to work at the nest—the one spot that a bird must return to over and over again. But most birds will not return, no matter how strong their maternal or paternal drive, if their nest is being overlooked by a human and some other strange three-legged animal. After working on nests and eggs as 'wildlife' still-life subjects, the Keartons eventually adopted disguise as the solution to their problem. They worked one nest by hiding themselves inside the mounted skin of a cow. On the moors of northern England they thought that a sheep would be appropriate, while in woodland they became a tree. Here then were the earliest photographic hides, or blinds as they are known in America. Soon it became apparent that such elaborate artifacts were unnecessary and that birds would take no notice of a simple canvas tent, provided it was introduced to them gradually and was not allowed to flap about. Thereafter, bird portraiture was dominated by the rectangular tent—one might almost say it was hide-bound. Over the years almost all British birds have been thoroughly worked at the nest, most European species have been photographed and perhaps nearly half of the world's birds.

Subsequently, the most important change was the introduction in the 1930's of electronic flash bringing with it three main advantages. The bird photographer could now work independently of the weather, and particularly of the British

summer with its alternate clouds and bright sunlight. He could also now take photographs of birds at night, and the whole dramatic area of owl photography was opened up. While short duration flashes up to 1/5000th were found to be sufficient to stop a small, fast-flying bird in its 'tracks' in mid-air.

Though the introduction of high speed flash is undoubtedly the most revolutionary change to affect bird photography, the improvement of equipment and film has gradually opened up fresh opportunities. Although the nest is the primary draw on the bird it is not the only one. Birds will come to food placed out for them, they will use a bird-bath for drinking and bathing, and at some spots they are so numerous a few must eventually pass within camera range. The realisation of these opportunities, and particularly the introduction and wide-spread use of the 35mm and 2¼″ square SLR cameras, has been responsible for the division of bird photography into five major types.

1. The portrait of the bird at the nest.

2. Photographs of birds, usually island or Arctic-Antarctic populations, that are so tame that a hide is completely unnecessary, and stealth irrelevant.

3. Baiting involves attracting the bird to the photographer, usually by means of providing food regularly.

4. Wait-and-see photography, where the hide is positioned at likely spots but where the photographer does not know exactly what will turn up, what position it will adopt, or whether it will ever return.

5. Stalking for photographs facilitated by the ease of handling of the SLR camera and the opportunities that this gives to the field ornithologist to record what he sees.

We shall deal with each division in turn bearing in mind that photographing subjects as small as birds, that by virtue of the power of flight are as mobile and fast moving as any other animals, presents so many problems that every wildlife photographer is interested in their solution. Few other photographers have to adopt such elaborate means and go through such painstaking preparation to achieve their ends. Most bird photographers could probably turn their hand to other

branches of wildlife photography—the reverse is not so simple.

Nest Photography

The first problem with this type of photography is to find the nest. Some bird-watchers seem to be constantly finding nests, whereas others seldom do so even when they attempt it. Nevertheless, there are several well-tried methods of nest finding depending on what species of bird you are working.

Finding the Nest

If lapwing, redshank or some other ground-nesting birds are sought the photographer must simply watch over likely habitats while concealed, and wait for the bird to return to its nest. The eggs of these species are so wonderfully camouflaged that unless the spot has been well marked in your mind's eye you will still not succeed in finding them, even though you may pass within a few feet. The best method is to line up two landmarks behind the nest, say a bush and a tree, and then walk to the nest keeping the marks in line. Even then beware of treading on the unnoticed nest.

The nests of smaller birds are best found after the eggs have hatched. For while the waders produce nidifugous young, that is the chicks can walk and feed themselves almost from the moment they are hatched, most passerines hatch naked and helpless and have to be fed by their parents. It is the frequency of visits of birds carrying food that offers the greatest chance of finding the best site for photography. Watching a parent bird back to its nest can be comparatively simple, but some species, like the grasshopper warbler, are notoriously difficult. These birds alight with food several yards from the nest and run the remaining distance hidden by vegetation. A similar procedure is adopted on leaving, often in a different direction. Finding such nests is a matter of getting down on hands and knees and searching every likely tuft of grass, but even then the nest itself is frequently approached by way of a tunnel through the grass, and it is very easy to crush it with a hand or foot.

Other species, like the skylark, which nest on open ground

are, unlike the redshank, close sitters. A useful technique here is for two people to drag a rope over the area and flush the sitting bird. But techniques of nest finding are so varied that only a few examples are appropriate. Information is vital and the bird photographer must have a sound understanding of his subject. He should read widely not only to obtain basic data about habitat preferences, the timing of the breeding season and so on, but also to get a feel for the bird so that he almost knows instinctively whether an area is right or not for his quarry.

Field experience is even more important. Finding the first nest of a species can be a lengthy ordeal, but having found one the photographer will find that the second and subsequent nests become progressively easier. Eventually he will almost look at a landscape with the eye of the bird itself, and avoid wasting time on fruitless searching.

Local knowledge is very useful and we have found that gamekeepers are often a very valuable source of information. Living as close to nature as anyone they do not always part with their secrets as quickly as one would wish. Spending time getting to know a good 'keeper is not time wasted, though it often seems that rambling chats are getting nowhere. A good 'keeper will know of dozens of nests, not only of his pheasants but of a wide variety of other species. He will know where the local sparrowhawks and kestrels breed, which barns hold owls and even the state of their eggs and young. A 'keeper is not the best paid worker in the countryside and even a modest tip will be valued; it will also ensure a welcome next time the photographer calls.

Some birds are so scarce that finding the nest is secondary to finding the bird itself. In Britain a special licence issued by the Nature Conservancy is required to photograph rare birds, which are listed on a special schedule (Schedule One)*. This section of the 1967 Bird Protection Act is simply a device for controlling disturbance at the nest of birds that are, to some extent at least, in danger of local extinction. We do not think that marsh harriers should now be photographed at the nest in

*See Appendix C, page 169.

Britain. Only a few pairs exist and they are particularly sensitive to disturbance—besides which they are numerous and easier to work abroad.

M. D. England, and G. K. Yeates before him, have specialised in photographing birds in Europe that are either extremely rare or which have never been photographed before. Until Derrick England photographed black-winged kite in Portugal the text books merely stated that this bird 'may breed in Iberia'. His pictures are not only first class, but represent three or four years really hard work corresponding, researching and working in the field. Similarly his pictures of the great bustard at the nest are an outstanding achievement.

Before we photographed the lammergeier in Spain we had spent days searching for the nest in a huge area where the birds had been reported. One day we would see a bird disappear over a hill, so the next was spent on the other side and so on until five days later the nest was found. Greenshanks' nests are notoriously difficult to find and we have the greatest admiration for Desmond Nethersole-Thompson who tracked down and studied so many of these birds that he was able to write a monograph about them. Finding some nests is pure luck. It is, for instance, impossible to track down a woodcock. The photographer simply has to find a likely area of woodland and then tramp back and forth until he flushes the sitting bird, or perhaps he will be fortunate enough to get a forester or 'keeper to show him one.

Selecting the Nest

Many nests are unsuitable for photography and no matter how much 'gardening' is done the results will not be satisfactory. In the case of common species it is as well to pass up an awkward nest and find another.

A good photographic position is, for preference, on the south side where the lighting conditions are best, bearing in mind that direct sunlight creates harsh shadows that are difficult to cope with photographically. Species like the redshank nest in tufts of grass, and the photographer will want to

find one where the easiest way of opening up the nest is on the south side. Most ground nesting species have a definite route to and from their nest which creates a track, and by placing the hide at right angles to it the photographer can obtain shots of the birds in profile as they arrive.

Having found a suitable nest, and you may have to find half a dozen before you find one that is perfect, a certain amount of 'gardening' is inevitable. Twigs or grass will obscure the sitting bird and give an unpleasant, out of focus foreground in the finished picture. As far as possible such material should be tied back out of the way, rather than cut off. Cutting with a pair of secateurs permanently removes cover and protection from the sitting bird, making the nest more obvious to predators, and in greater danger from the direct rays of the sun and chilling winds. Tying back enables the nest to be opened up to the eye of the camera, while allowing material to be replaced at the end of each session. There are, of course, occasions when foliage must be cut, but this should always be a last resort. As far as possible cuts should be made diagonally, on the side of the branch away from the camera. The exposed white inner surface of even a small twig will appear as an unsightly spot or blur on a photograph. In cases where cuts cannot be made at the correct angle they should be smeared with mud.

The basic rule is to try to make working a nest as easy as possible for the photographer and, by doing so, as easy as possible for the bird. The least interference with a nest the safer it will be. There is, for example, absolutely no point in constructing a small pylon hide, with all the disturbance that this can create, if it is possible to find another nest of the same species that is closer to the ground. Least disturbance is a general and unbreakable rule.

In the first flush of enthusiasm the would-be bird photographer is often attracted to the more unusual and difficult species. It is, however, absolutely essential that he starts with the commoner birds that nest either on the ground, or in low bushes where there is no need for elaborate structures. Like other skills the technique of bird photography needs training and practice. There is no point in starting on a peregrine

which will require a licence, much research, an elaborate hide and may very well lead to desertion by the birds. Learn the trade on robins, blackbirds and starlings, and get your technique right before going on to rarer species. The same advice equally applies to all wildlife photography.

Start photographing then with the smaller, more common birds and progress forwards by working tricky subjects like lapwings, where too much haste can easily lead to failure. It might then be appropriate to attempt some of the tree-nesting species like woodpeckers, crows or rooks where a more elaborate hide is required. At all costs leave the rarities alone until you have justified the right to face them. An apprenticeship of four or five seasons is not too long. Desertions, particularly of scarce species, not only prevent the taking of pictures but give all bird photographers a bad name. Many of today's greatest exponents served their apprenticeship with an earlier generation of photographers, but even without a guide and philosopher the beginner can learn a great deal away from the nest, particularly at bird colonies.

Bird Colonies

Colonial birds such as gannets and guillemots often permit a sufficiently close approach that a hide is unnecessary. They offer a huge choice of subjects and the photographer can set up his tripod with the sun shining over his shoulder and with a telephoto lens get 'hide-quality' results. There are also opportunities to photograph behaviour in the form of aggression, greeting ceremonies, take-offs and landings, and so on. With so many subjects to choose from there is always something of interest to photograph.

The same opportunities can be found at colonies of gulls and terns, except that here it is usually necessary to erect a hide. This is best positioned at the edge of a colony because of the danger of treading on eggs while searching for a centrally positioned nest. Colonies provide opportunities to photograph a wide choice of subjects in comparative ease.

The Timing of Photography

All birds are best photographed at one time rather than another. Ground nesters, and waders in particular, hatch and are soon very active. These species are best photographed on eggs. Unfortunately, at this stage they spend most of their time incubating which provides few opportunities for a variety of poses, although patience is often rewarded by shots that are otherwise not easily obtained. If at all possible the photographer should try to time his work to coincide with the hatching period. Then, not only do the parents change over more often, but they are excited, inspect the eggs frequently and there is an opportunity to obtain shots of both parents together, and the pair with their young before they leave the nest.

Many chicks cheep inside the egg before they hatch, and the first attempts to get out of the egg result in 'starring' where they are starting to break through. The photographer should take due note of such evidence—he usually has at least 48 hours to set up his equipment and settle down for a long vigil.

Passerines, too, present a somewhat unexciting spectacle sitting on their eggs hour after hour, and again it is advisable to work immediately after the hatch. With many birds the hen will stay on the nest brooding the young, leaving the cock to search for food. When he returns, not only are the pair of birds at the nest, but the cock will feed the hen which may then, in turn, feed the young. Certainly nests are easier to find when the parents are carrying food. But watching a bird carrying nesting material back to the chosen site can be a very effective means of finding a nest, which can then be followed through the nesting cycle and 'worked' as appropriate.

Hides

Though hides can be of all manner of shapes and sizes and constructed of a variety of materials, every bird photographer should possess a few specially constructed 'standard' hides. He

should also carry with him a collection of pieces of sacking or cloth, and a multiplicity of safety pins and string for improvisation.

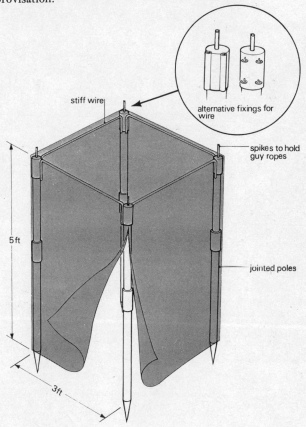

stiff wire

alternative fixings for wire

spikes to hold guy ropes

5 ft

jointed poles

3 ft

Figure 5. Hide design and construction

The standard hide is a rectangular upright tent with a base some three feet square, and some five feet in height. This is quite sufficient to accommodate the photographer and his comfortable stool, preferably with a soft cushion, the tripod

and camera, the photographic bag or the rucksack and a selection of amenities like food and a Thermos of hot or cold drink according to season.

Our best hides are made of a heavy canvas (too light a material will enable the bird to see the photographer in silhouette with the sun behind him), on a framework of telescopic alloy tubing that fits together like a continental frame tent. Though a latrine tent with modifications will do, we have found that it is far better to start from scratch purchasing the canvas, poles and parts from a tent manufacturer and getting the design absolutely right. There are several commercial manufacturers of photographic hides.

The hide should open at one corner and there should be flaps or nurse's sleeve holes for the camera lens on each side. Nurse's sleeves have the advantage of insulating the camera from wind buffeting on the hide itself, and thus enable the camera to be kept really still. A selection of peep-holes enables the photographer to see what is happening outside, without having to look through the camera. The entrance is best sealed with large safety pins or cord ties, and the canvas must be pulled tight so that the hide does not flap in the wind and disturb the birds, whether the photographer is in position or not.

Of course, many species nest high in trees, barns, cliffs and so on. Here it is necessary to construct a platform at the correct height on which the hide can be mounted, though it may be possible to improvise a hide in the branches of the same or even an adjacent tree with canvas and pins. It is, however, often impossible to improvise in exactly the right position for photography and it becomes necessary to resort to the pylon hide. For medium-height nests, up to fifteen feet, we carry a set of lightweight scaffolding. For higher subjects, like the lesser spotted eagle which we photographed in the top of a sixty-foot tree in Bulgaria, we felled four roughly comparable trees and nailed and lashed them into a square with cross pieces.

By and large tree-top species are shy, and in the same way that a ground hide must be moved up with the greatest of care, so must the pylon be introduced to the birds gradually over a period of days. Putting the uprights in place and securing them

is sufficient for one day. Then if all is well the majority of the cross struts can be added. Then the platform and finally the hide. If the birds do not accept this growing monstrosity next to their nest it should be immediately removed. We like to work in shifts of a maximum of three-quarters of an hour, assembling all the materials nearby before we actually start work, and it should be remembered that although a pylon rising beside its nest is going to disturb the bird the sudden appearance of the hide on the top is the biggest shock of all. We invariably erect the hide itself to half height at first in an effort to minimise the impact.

Sometimes the photographer will be lucky enough to find a horizontal fork in a tree that overlooks the nest on which a platform can be constructed. Ideally the platform should be at the same height as the top of the nest, enabling the camera to look slightly down into it giving a more natural look and avoiding highlights from the sky.

Some photographers have managed by hanging canvas like a screen around themselves while they sit astride a branch, but we have always believed that the greater the comfort of the photographer the better the results that will be achieved. If a site in a neighbouring tree is usable it is a good idea to link the hide tree and the nest tree so that they move together in the wind. A strut from one to the other prevents the subject from coming in and going out of focus as the trees sway.

Pylon hides are never cheap but we obtained our alloy scaffolding at an auction of a defunct film company, and on several occasions we have hired commercial scaffolding from a local builder at quite reasonable cost. Once we even got some builders to erect the pylon under our instruction and it was staggering how quickly they worked. In fact we had to stop them from getting too much done in the time we had allowed.

Specialist hides cover a wide variety of photographic improvisations including mounting the hide in a rowing boat where the subjects are aquatic birds like grebes. On occasions we have constructed a hide by sinking supports deep into mud but often a boat is far more simple though perhaps less steady. Pushing four poles well into the bottom mud against the

gunwales and tying the boat firmly to them overcomes most of these problems. It is quite possible to use a boat as the base for the wait and see technique, and also for stalking by what amounts to the old punt-gunner's technique. The latter will need the help of an assistant to approach the subject while the photographer remains well-hidden in a hide mounted forward in the bows.

One of the problems with photography afloat is the ease with which the horizon can be misaligned. This did not matter too much with black and white film because it could often be straightened up in the dark room, but with colour there is only a minimum of masking and much less lee-way, while with cinématography it is quite impossible.

Hides in boats, hides on pylons, hides suspended over cliffs, there is no limit to what can be done by the determined and inventive mind. The serious photographer will utilise a number of standard hides during a season. On several occasions we have had all twelve of our hides up at the same time in various stages of preparation and working. Twelve may seem a lot but three seems the absolute minimum.

Working the Hide

Having found the right nest the hide is erected at a considerable distance depending on the species, and over a period of several days it is gradually moved nearer and finally into photographic position. With a robin an initial distance of ten yards is quite adequate and the final shooting distance will be four to six feet. Tame species like the blue tit will sometimes visit their nest while the hide is being erected and it can be moved up to photographic range there and then. Other species demand more care and patience and a far longer preparation period. It is often advisable with such birds not only to start at a considerable distance, say thirty yards, or even more, but at first to erect the hide at only half its normal height. At all times the safety of the bird must come first. Every move should be checked to see whether or not the subject has accepted it. If not withdraw and always be prepared to give up altogether and

find another more obliging bird. Above all, remember that birds vary in temperament almost as much as humans, and while one pair of birds will take no notice of a hide, another pair of the same species will not come near their nest with a hide nearby.

When a bird first returns to its nest do not take a photograph. Use the opportunity to study its behaviour carefully. In the case of a passerine make a note of where it perches, for it will usually land on the same place each time it returns to the nest. Watch the young and see whether there is a lot of movement when they are begging and if this dies down after a little while. Watch the method of feeding. Does the adult push the food right into the mouth of the chick or does the chick take the food from the parent? After feeding does the bird fly away immediately or does it stand still on the rim of the nest waiting for the young to defecate? When a wader returns to its nest it will usually run a few yards, then stop, have a look round, perhaps false feed, then come a little nearer. When close to the nest it will usually run the remaining distance without giving the photographer a chance of getting a shot. Often by making a slight noise, such as sucking air into the mouth or making a squeak, the bird will hesitate a moment before settling over the eggs. This is the moment to fire the shutter. Watch and note all such manners so that when photography is commenced you will know exactly what to expect and be fully prepared.

Before you fire the shutter for the first time wait until the parent is preoccupied by actually feeding the young or settling over the eggs. She will probably look up suspiciously. Sit tight and hold your breath. Do not attempt to wind on the shutter until she is relaxed again. If the bird does leave the nest let her return and do not make another exposure until she has regained her confidence.

With most SLR cameras the flap-up and return of the mirror makes quite a considerable noise and if the bird is the least bit nervous this may send her away in a panic. Try, therefore, to obtain a camera in which the mirror can be locked-up so that the only sound the bird will hear is made by the shutter. Perhaps the noisiest cameras of all are those with

motor-drive. Dr. Victor Hasselblad is a very keen bird photographer and has arranged a selector dial on the Hasselblad EL so that the mirror can be raised and kept up. The only sound the bird will hear, if indeed it can hear anything, is that of the Compur shutter. If pressure is maintained on the release until the subject leaves or is distracted it will prevent the whirr of the film being wound on disturbing it. This method is particularly useful when working by remote control. After the exposure has been made the film can be prevented from

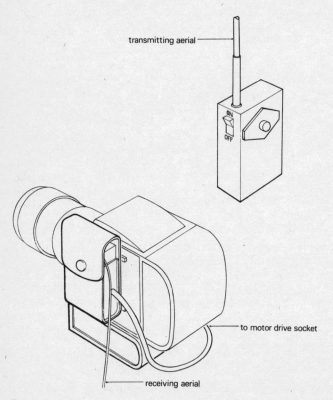

Figure 6. Motor drive and radio control on Hasselblad camera

winding on until the bird has finished feeding its young and flown away.

With or without motor drive the birds will become used to sounds coming from the hide after a few exposures and will ignore them. The important fact is to train them to become used to slight noises. This preliminary work will make all the difference between a series of really good photographs of relaxed birds and just one or two of them scared out of their wits.

Note-books

Using several hides requires meticulous note keeping. Moving up, as well as working at the optimum moment, must be arranged to a schedule. But even inside the hide note taking is important. The bird photographer is in a unique position to study and record the most intimate details of a bird's life. Though the main purpose of being there is to take photographs he should not let opportunities pass him by. He can record the roles of the sexes in breeding or incubation. Which collects the food? How many eggs are there? How many hatch? Such details not only add interest to the pictures but are valuable in their own right.

Photographing the Birds

Many bird photographers are satisfied with one perfect picture but we prefer to obtain a series if we can, including both sexes at the nest, single portraits of each sex and finally shots showing the development of the young. This does, of course, require long periods in a hide but we feel that the disturbance caused by entering and leaving is such that a four-hour vigil is, in any case, advisable.

A further reason for making a full series is that having introduced the birds to the hide it could be a serious shock suddenly to remove it. We prefer to leave the hide in position until the young have flown, and by so doing take advantage of its presence to enjoy further opportunities for photography.

Photographers with only a few hides must use as much

caution in withdrawing them as they did on working-up. The time required will, of course, vary with the circumstances. On a bare heath a hide is a prominent landmark and must be introduced and withdrawn with great care and patience. In a woodland the whole process can be significantly speeded up without danger to the birds.

While working small passerine birds and seeking a complete series of photographs the hide is often ideally sited for shots away from the nest. Most birds approach their nest along an established route, perching somewhere prominently for a look around before dropping down to feed their young. By introducing an artificial, but attractive and natural-looking perch a short distance from the nest and the hide, but along the already established approach route, a whole new area of photography is opened up. The birds will readily take to such conveniences and by careful siting, avoiding highlights in the background and so on, outstanding pictures can be obtained. It is, of course, as well to remove any natural perches which might compete with your artificial one.

Utilising an electronic flash and a photo-electric-cell trip device, shots of the birds flying to the perch can be obtained— but more of this in Chapter 4.

A perch four feet from the nest is ideal, and by careful planning the photographer can site one camera at the nest and one, angled, at the perch. If only one camera is used separate spells in each direction will achieve a similar result. Birds as varied as whinchats and shrikes will be photographed in this way, but hole-nesting species, like tits and kingfishers, have a habit of disappearing straight into their hole without any chance of a photograph and make ideal subjects for this technique. A perch erected two or three feet from the nest entrance is in most circumstances the only way in which photographs can be obtained at all.

Baiting

Photography at bait is an attempt to get the bird to come to the photographer rather than the photographer to go to the bird. The setting up of the hide, tripod, and flash equipment if

required, is standard save only that there is no need to introduce the hide gradually and the photographer is free to choose his own background.

A wide variety of baits can be utilised depending on the species that it is intended to photograph. A garden bird-table is a focus of attention for birds but does not make a very attractive or natural-looking picture. As at the nest, a perch nearby is often used for a quick check on the surroundings and this gives the photographer the opportunity to introduce his own perch and set up his hide appropriately. If the table is enclosed on three sides and roofed the birds are almost bound to use the perch on their approach to it. With a bird table cited outside a window setting up the hide may involve no more than drawing the curtains. Perches may themselves be baited with fat and seeds but these should be hidden from the view of the camera. Though seeds, suet and peanuts will attract a variety of garden birds in winter, in summer most of them can find sufficient natural food. But at all seasons birds must drink and bathe.

A bird bath has the same unnatural look as a bird-table but a drinking pool on the ground can be made to look quite natural and attractive. An old dustbin lid turned upside down with the rim flush with the ground and well masked with moss or mud serves as well as anything. The usual garden birds will be attracted but in summer moving water has a unique attraction for the warblers that can otherwise only be photographed on approaching the nest. A very slow drip of water can easily be arranged to fall into the pool thus keeping it permanently in motion. We have found that a five-gallon drum placed four or five feet above the ground acts as a reservoir for several days. A plastic tube fastened to a stick to hold it down is inserted through the top of the drum and run out over the pool. Sucking the water through creates a syphonic action and a constant stream of water pours into the pool. This can be controlled as a slow steady drip by using a spring clip near the end.

Photography away from the garden will involve putting up a hide, but if bait can be provided regularly then a semi-permanent construction may be worthwhile. Apples are an

excellent bait in hard weather and offer one of the few opportunities in Britain to photograph winter visitors like fieldfares and redwings. Corn put down at regular feeding spots by gamekeepers for their pheasants attracts many other species as well. But some of the most dramatic shots of all have been taken by putting down bait for large carrion-eating birds of prey.

Regular baiting of a specific spot with, say, a rabbit two or three times a week will attract raptors like buzzards if they are common in the area. The photographer who is unable to do this personally may find a gamekeeper who is willing to do so provided he is paid for the rabbits and his time. He will, of course, find it easier to obtain rabbits than most photographers. Before the last war H. G. Wagstaff obtained not only a superb 'series' of buzzards at various prey but also carrion crows, magpies, ravens and even a stoat. We have photographed vultures at larger carcasses in southern Spain, and by placing a perch nearby we managed to get shots of magpies waiting to pick up tit-bits dropped by the larger birds. During the making of the Royal Society for the Protection of Birds' film *The Kites are Flying* the film crew even managed to obtain an excellent footage of the red kite away from the nest at bait.

If there is one secret of success in this type of bird photography it is regularity. Regular feeding in unchanging surroundings where the hide is left permanently in place so that it becomes as much a part of the landscape as any other object is the key. Apart from positioning the hide for lighting and background it is also necessary, particularly with smaller baits, to peg-down the prey. Most raptors have a favoured 'plucking-post' to which they like to take their prey and a rabbit presents little problem to a buzzard which will simply remove it, giving the photographer only one, if any, satisfactory chance to obtain pictures.

Songs as bait

Though not strictly bait, attracting birds by their own calls is both successful and increasing in popularity. For many years American naturalists have used whistling devices to 'call-up'

birds. Now they are turning more and more to tape recordings played-back on the cheap mass-produced recorders that are so readily available. Naturally bird photographers were quick to see the opportunities offered to attract birds for photography.

The technique consists of entering a bird's territory and playing a recording of the species' song. A perch can be placed near the loud-speaker to which the subject will invariably be attracted. We say 'invariably' because we spent eight hours endlessly playing the European cuckoo's song one summer only to attract the bird eventually to sit on top of our hide. Later it behaved admirably and perched as planned for a whole hour giving us exactly the shots we were after.

Baiting can attract a wide variety of species and leaves a considerable amount to the ingenuity and knowledge of the photographer regarding both the bait to be used and the final composition of the picture.

Wait and See

'Wait and See' photography, someone once said, is all wait and no see. It can be very exhilarating but the photographer often has to invest a considerable amount of time in exchange for his moments of pure bliss. In many ways 'wait and see' is very much like baiting. Our friend R. J. C. Blewitt, for example, has spent at least a couple of seasons with his hide overlooking a forest water storage tank. Save only that he did not put it there himself, it worked in exactly the same way (if more excitingly) as a garden drinking pool. The photographer simply placed a branch from the bank into the pool and set up his hide to wait and see what came along. His pictures of jays, wood-pigeons and especially sparrowhawks bathing are first rate.

A photographer setting up his hide to 'wait and see' at any food source frequented by birds will get some results. Small pools always attract birds, particularly in a dry summer when drinking and bathing are so important. Grain spillages attract doves and finches, refuse tips attract gulls and crows, so there is no need to restrict photography either to a bird's nest or its food.

All birds sleep, many of them communally. Though most do so at night the 24 hour system of other birds is ruled not by the light but by the tides. Vast numbers of waders take advantage of the rich feeding provided by estuaries. While the tide is out they spread over the miles of exposed sand and mud. As the tide covers the banks and forces the birds to stop feeding they gradually accumulate at an established high-tide roost. At the Cheshire Dee, for example, thousands of waders that feed on the fifty square miles of flat sand and oozy mud are driven to find refuge on three tiny rocky islands at the mouth of the estuary. Though there are others Hilbre Islands are the major roost for the estuary. On the smallest of the islands, appropriately known as Little Eye, literally thousands of waders gather, presenting the bird photographer with an awe-inspiring sight and marvellous opportunities to take pictures. We have a picture that shows five thousand knot gathered round our hide—some birds were actually touching the tent, so tightly were they packed together. Any regular high-tide roost will provide similar if perhaps less spectacular opportunities.

The basic plan of work is to get to the site some two hours before high tide and set up the hide within range of the points where the birds first arrive. This enables the build-up of numbers and the gradual departure afterwards to be photographed. On rocky islands it is necessary to anchor the hide firmly in place with guys, while on saltings the problem of keeping dry feet becomes more important.

Wherever birds gather 'wait and see' photography can be practised but perhaps it is not surprising that many photographers have concentrated the technique on waders. They are usually quite numerous and often confined in their feeding; they are otherwise difficult to photograph except at the nest and, as many of them breed north of the Arctic Circle, even that is not easy. Additionally they have a peculiar attraction of their own, perhaps because they are bird-watchers' birds and usually go unseen by the general public.

Fresh-water waders are frequently numerous at sewage farms in autumn. Almost every lagoon will attract some birds

but it is crucial for this form of photography to get to know the farm and keep up to date with what is happening. No matter how many lagoons are available the majority of birds will invariably prefer feeding on one of them—this is the place for the hide. But remember that the lagoons may well be flooded as part of the general everyday working of the farm, and that permission is required to enter a farm and to set up a hide. Like a good gamekeeper the good sewage farm manager is worth cultivating.

Careful watching over a period of days will show where the birds are concentrated and where the ideal spot for the hide should be. Sewage sludge is, however, often somewhat soft and gives off an unpleasant odour. Test carefully before venturing on to the 'marsh' and remember that birds may present themselves for photography on any side. Imagine the frustration of not having a lens flap at the rear of the hide when the sixth British Terek sandpiper turns up!

Fresh marshes can be worked in the same way, and wooden hides erected at reserves and refuges to enable people to see birds also enable the photographer to photograph them. It is usually necessary to work with a lens of at least 500mm but at the right time of the year it can be very rewarding. We have spent many happy days in wooden hides at the Royal Society for the Protection of Birds' reserve at Minsmere and obtained hundreds of pictures of waders, gulls, terns and ducks.

A car can perform very valuable service as a wait and see hide. Brian and Sheila Bottomley frequently use this technique, stopping when they see a likely bird and waiting to see if it will come closer. Inevitably long focus lenses need to be used and one of the major problems is to keep the camera steady. A home-made structure to fit on the car window and provide a ball and socket head is well worth the time and trouble of making. The back of a car or Landrover can be converted into almost a normal-type photographic hide with peep-holes and holes for the lens, and of course a hide in a boat is useful for aquatic 'wait and see'.

Stalking

Stalking birds is like stalking mammals with one important difference—birds are usually smaller and thus require longer focus lenses or a closer approach. Though photographs were obtained by stalking thirty and forty years ago it really is the advent of the 35mm and $2\frac{1}{4}''$ square format that has opened up this area for a host of new enthusiasts. Literally thousands of bird-watchers now include a camera and a big lens along with their ordinary equipment, and carry it with them in the hope of coming across an interesting bird within photographic range. Between them they must expose miles of film each year and inevitably by the sheer law of averages obtain some good results.

Some photographers have concentrated on stalking and here again Brian and Sheila Bottomley come to mind. Their results are excellent and they have carved a unique niche for themselves by specialising in the photographing of passage migrants and rarities. In fact they have taken pictures of more American vagrants in Europe than many American photographers have achieved in their own country.

Sweden has produced a whole generation of first rate stalkers who, perhaps because of a realistic assessment of the light that is available in these northern latitudes, tend to specialise in fast black and white films. Of course the tameness of many Arctic breeding birds is also a significant factor in summer, and with many species like the waders and skuas it is not necessary to erect a hide at all.

Equipment for stalking is invariably the SLR camera with a 300mm, 400mm or 500mm lens. It is possible to stalk birds with shorter lenses but the number of species that will allow a sufficiently close approach is limited. A shoulder support with a built-in cable release is almost essential, allowing the camera and large lens to be held firmly and steadily. Because of the hand-held factor speeds of at least 1/125th are required with the longer lenses, often considerably faster because of the nature of the subject. The longer lenses of 500mm to 1000mm become progressively more difficult to hold still, and many stalkers are adopting the light and more manageable mirror or reflex lenses in spite of their fixed apertures.

Many of the photographs obtained by mirror lenses have a series of small bright circles in the background. Often these do not intrude and in any case can be touched out on the finished print in black and white work. No such action can be taken with a colour transparency and we have seen what were otherwise excellent photographs ruined by a mass of eye-catching white rings. A dark background creates rings that are insignificant and often difficult to see even with magnification but a light background, particularly with highlights or move-ment, can ruin the best transparencies in this way. Some photographers do not find a background of rings unpleasant—we do and seek to avoid it as far as possible.

Most stalking photographers specialise on ground or marsh birds like waders, gulls, duck and geese, but it is quite possible to stalk smaller birds. We have seen remarkably good pictures of larks, chats, buntings and even the tiny warblers. Such species do require a great deal of care in the approach and even with the large mirror lenses the photographer must get within ten feet or so of his subject. The stalking technique has, however, been emancipated by the advent of first class 35mm and $2\frac{1}{4}''$ square equipment and there is now no subject that is beyond the scope of the skilled photographer. Even small birds singing are being photographed wild and free.

African elephant at the Kilaguni Lodge waterhole, Tsavo National Park, Kenya. The atmosphere of safari is evoked by animals set against such magnificent backdrops

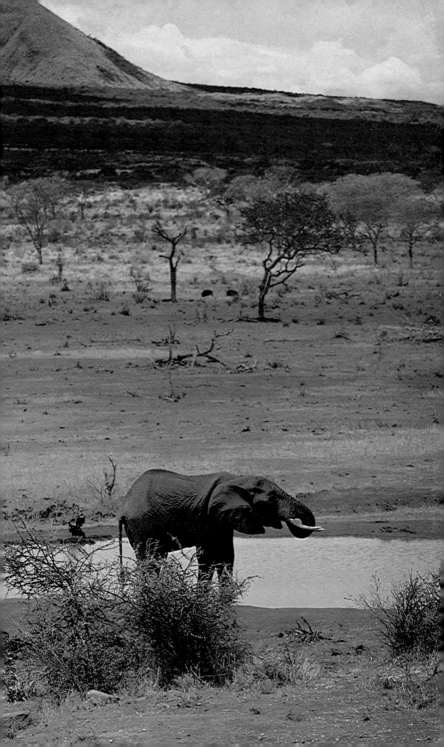

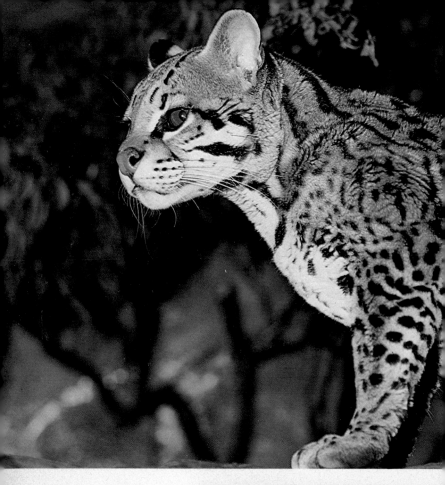

Zoos and wildlife collections provide opportunities for more intimate studies.

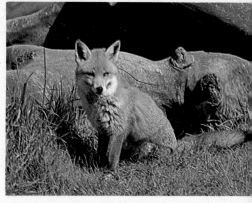

The ocelot was shot by flash through glass whereas the wire at the front of the fox's cage was completely blurred out of focus

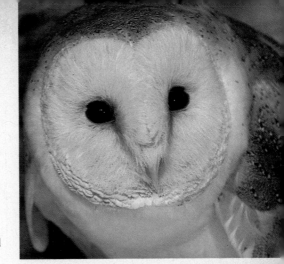

Really dramatic close-ups of animals are highly effective, even if taken under controlled conditions like this barn owl

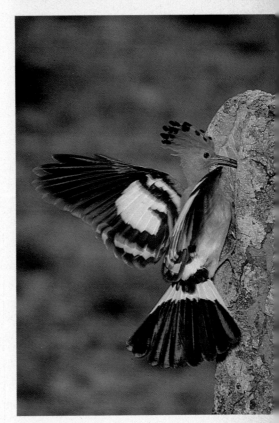

The use of a powerful flash unit, giving an effective speed of 1/1400th sec, has almost stopped the movement of this African hoopoe at its nest

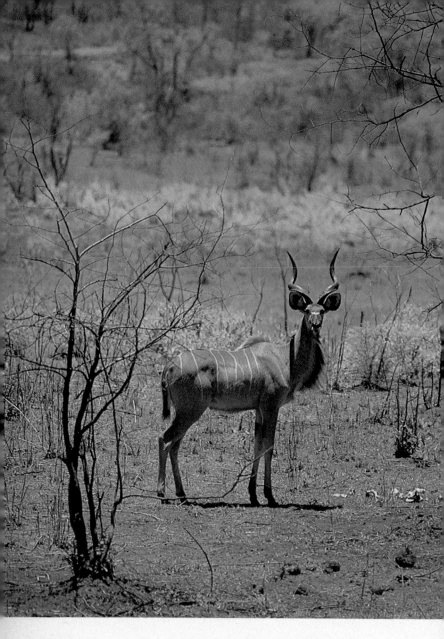

The greater kudu is one of the scarcer African safari subjects, being both solitary and skulking. This one was taken in the Wankie National Park, Rhodesia

4 Flash

The use of artificial lighting in photography is so widespread that it would be rather surprising if the wildlife photographer did not take advantage of the many benefits that it offers. In particular the standardisation of illumination enables him to concentrate on catching his subject in the best pose, rather than waiting for a cloud to pass or for the mammal or bird to move out of shade. Colour film is particularly prone to alter its colour rendering with differing natural light. Cloud, for instance, increases blues, and a UV filter is required to eliminate a blue cast. Electronic flash disposes of the problem of colour variations by producing a completely standard source of illumination, enabling the photographer to concentrate entirely on his subject. While it is, of course, quite possible to floodlight subjects, the preparation is so elaborate that most photographers other than cinématographers prefer to use short flashes of light triggered to synchronise with the making of the exposure.

The use of high speed flash is without doubt the most revolutionary change that has affected wildlife photography since the invention of the hide. Not only does it enable pictures to be taken irrespective of sunlight conditions, but it opens up whole new areas of photography that were previously closed. In particular, it enables the photographer to work nocturnal animals like owls and many of the small mammals; take action-freezing shots, even of subjects like birds in flight; and of very small subjects where a close approach with natural lighting severely restricts the depth of field. These opportunities have radically affected both the subject and standard of natural history photography in the last twenty-five years.

The earliest flash photographs were taken by igniting up

to two pounds of magnesium in a huge smoky explosion that was bound to be followed by the disappearance of the wild life subject for a considerable period of time. But even with six ounces of magnesium J. A. Speed obtained some excellent photographs of swallows in flight in 1929.

Bulbs

Flash today can be divided into two main types—bulbs and electronic. Both are synchronized with the release of the shutter. Bulb equipment is cheap, but running costs in the form of disposable bulbs are high. Each bulb is used once only and has to be replaced before further exposures can be made. The act of replacement can be a great disadvantage when working from a hide, when at least an arm has to emerge from hiding to replace the bulb between each shot. Not surprisingly many subjects do not take kindly to this operation, and are liable to disappear for lengthy periods as a result.

Bulbs also suffer from being synchronised with the modern 35mm camera at only one speed. With the older types this was as long as 1/25th or 1/30th, but on more recent models it can be 1/125th. Nevertheless, when used to provide fill-in light in areas with some natural lighting, such as woodland, there is always the danger of a double-exposure creating a ghost-image produced by both the natural lighting and the flash being sufficient to partially expose the film. Bulbs can be useful to illuminate backgrounds and avoid a spotty effect but, though often more powerful than electronic flash, their limitations are such that anyone entering the field of artificial lighting is strongly recommended to go for the more initially expensive electronic flash.

Electronic Flash

Twenty years ago Hosking and Newberry described the electronic flash revolution in their book *Birds in Action*. Beneath the excitement at the new fields of photography opened up to them, there ran a barely expressible feeling that

the huge cumbersome equipment required had limited their scope and thus, to a certain extent, the carefree enjoyment of their pursuit. The huge batteries weighed about 30 pounds, and even these were a compromise between what they would have ideally liked, and what it was possible to transport. Even divided into three units for carrying by two or more people, there were considerable restrictions on the distance from roads that could be worked. Present day sets are not only comparatively cheap but they have been so reduced in weight that there is positively no limit to their use. They are both portable and powerful, and thus ideal for wildlife.

Electronic flash was developed by Professor Harold Edgerton and his team at the Massachusetts Institute of Technology in the early 1930's, and was first used to study high speed machinery. Power is supplied by a battery via a high-ratio transformer where the output is rectified and used to charge a large capacitor to some 2500 volts. This voltage is then discharged through a glass tube filled with gases such as Krypton or Xenon, or mixtures of both. With the action of the discharge the gases glow very brightly for a brief period varying from a 1/500th to less than 1/10,000,000th of a second. Of course, to be of any use, these extremely short duration flashes depend on very powerful sources of electricity, and most of today's commercially available sets produce a flash varying from 1/500th to 1/1000th of a second. These sets are of exceptional value to the wildlife photographer, but for real action-stopping, such as a small bird in flight, we had to have a set specially built to give a flash duration of 1/5000th sec. which is fast enough to stop even the wings of a bird flying at twenty miles per hour. We would like to see a manufacturer produce a similar set commercially. Though electronic flash gives out less light than bulbs, its shorter duration enables all of the light available to be used, whereas only a part of the power of a bulb can be used during an exposure of say 1/125th.

One of the drawbacks of the earlier sets, apart from that of weight, was continuous charging. A press photographer could switch on his set just prior to taking a picture, but the wildlife specialist never knew from one moment to the next when he

would have to shoot and had, therefore, to keep his set switched on at all times with consequent discharge of the batteries. This problem was overcome by 'topping-up' every minute or so with a short burst of power. Fortunately most modern sets now have a built-in cut-out cut-in, that automatically keeps the charge at the correct level ready for instant discharge. We are thus ready once the set has been switched on and the charge built up.

Uses of Flash

It is our considered opinion, based on over twenty-five years of work, that natural lighting is to be preferred to any artificial source. It gives a more pleasing and realistic result, but there are many occasions, particularly in bird, mammal, fish and insect photography, where natural daylight is insufficient for the photographer's requirements. Working in woodland, at a nightingale's nest for example, with a modern high resolution colour film like Kodachrome 25 with a rating of 25 ASA, the light penetrating the trees may be sufficient to give an exposure of only 1/5th sec. at f5.6. To get the nightingale absolutely still at this speed will involve considerable wastage with shots spoilt by movement and, of course, at f5·6 the depth of focus is so small that many shots will be ruined by lack of sharpness through the whole subject. This factor is particularly important when photographing small subjects where a close approach is necessary. Work on the smaller fungi, for example, requires the use of a bellows, extension tubes or a close-up attachment, often in very dark surroundings. At f5·6 at a range of six inches the depth of field is so tiny that it is quite impossible to obtain a sharp picture of the whole of the subject. Only by using flash and stopping the camera down to f16, or even f32, will the photographer stand any chance of obtaining a really crisp result with every part of the subject in focus. Thus for photographing woodland birds and photo-macrography alike, electronic flash is a tool that few modern practitioners would care to do without.

Such examples of insufficient natural lighting are the areas

where the normal commercially available sets come into their own. An exposure of 1/500th is quite sufficient to swamp the available daylight, and avoid the danger of ghosting mentioned above. These sets are also quite adequate for illuminating subjects at night and here, though the principles remain the same, we enter a field of photography that is quite impossible to work without artificial illumination.

Many creatures like bats, badgers, foxes and, of course, some species of birds, are nocturnal. Though most night work has been done on owls we have been very impressed by Ernest Neal's pictures of hyaenas taken at night in East Africa, while both he and others have worked nocturnal British mammals very thoroughly.

Working at night is very similar to working with flash during the day. The same preparation of hide and equipment is necessary. It is, however, important to choose a moonlit night so that the photographer will know whether the subject is before his lens or not. Or whether he is taking a picture of the animal's head or tail. Inevitably he will have to pre-focus on the spot where he expects the animal to be.

Owls have always been one of our favourite subjects. Photographs of these birds at their nest is one thing, pictures of them in flight present a whole different range of problems. How, for instance, will the photographer know when to release the shutter and fire his flash? How will he know when the subject is before his lens and in the correct plane of focus? Will he be quick enough to release the shutter before the subject passes?

Birds in flight, and bats as well, move so fast that the human eye, brain and fingers just do not function fast enough to catch the subject as it passes, let alone get it correctly framed and in focus. It is thus necessary to use an automatic trip of some kind, though we do know of one photographer who could react swiftly enough to obtain pictures of a chameleon's tongue as it flicked out to catch an insect without resort to such devices.

The bee hummingbird flaps its wings at a rate of 180 beats per second and an exceptionally fast flash is required to freeze it. For most small birds, however, a 1/5000th sec. is quite

sufficient to show every barb of even the fast moving primary wing feathers.

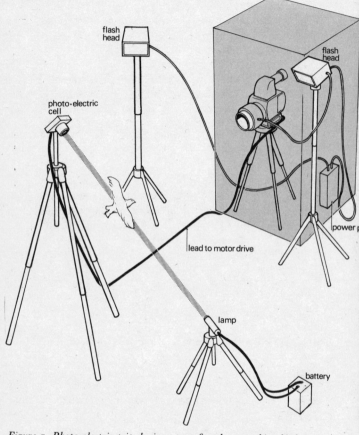

flash
head

flash
head

photo·electric
cell

lead to motor drive

power p

lamp

battery

Figure 7. Photo-electric-trip device set up for photographing birds in flight, using low-voltage rechargable accumulator

Automatic trips, or photo-electric-cells as they are known, work on the same principle as automatic doors at airports, modern supermarkets and hotels. A narrow beam of light is thrown from a lamp unit on to a photo-electric-cell. When the

beam is broken the shutter is released and the flash fired. Thus all that is required of the photographer is to sit back and wind on the film after each exposure. Even this function can be eliminated by the use of a motor-drive for the camera. We know of photographers who do not bother with a hide at all, setting up their gear and retiring to the comfort of their home or hotel for an hour or two. The skill here centres around the ability to locate the subject, and introduce and set up the equipment in such a way that the bird will accept it and take its own picture regularly in an attractive pose. Perhaps the skills involved are even more complex than simply sitting in a hide in daylight and operating equipment manually.

Working with Flash

There are thus at least three distinct uses for electronic flash: where natural light is insufficient; where natural light is totally unavailable with animals that are nocturnal or which live in caves; and for freezing action of highly mobile animals like bats or small birds in flight.

To return to our nightingale in woodland. Having found the nest, chosen our viewing angle and moved up our hide in the usual way, we then have to introduce the bird to the flash units themselves which must of necessity be outside the hide. As with moving up the hide, it is as well to do this gradually. Unfortunately, flash heads are expensive and, while the risk of them being stolen can be minimised, though never ignored, they will suffer in bad weather. Shiny replicas are best used, either redundant or broken car headlights, or tin cans drilled and bolted to fit the tripods. Most birds are not put off by this paraphernalia though some individuals take a dislike to them, possibly by seeing their own reflection, and become impossible to work.

Some photographers make do with a single flash head, but we find the harsh shadows thrown by the subject are better eliminated, and a more 'modelled' effect given by the use of two heads. If only one head is to be used it should be placed as near to the taking lens as possible. With two heads we like

the main one near the camera but slightly higher, with the secondary head farther to one side and at a slightly greater range. Distance from the subject will be dependent on the object itself as well as on the power of the set, but three and a half feet is about the minimum that most subjects will permit with the secondary head a foot farther back.

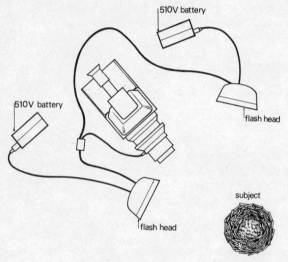

Figure 8. Plan showing flash positions and camera relative to subject, using 510V disposable batteries.

Two heads can usually be fitted to a single power source though, because both power and speed are halved, we prefer to use two separate sets triggered by a two-way cable connected to the camera synchronisation boss. In fact we often use a third set to illuminate the background where this is too far away to permit adequate lighting by the two head outfit. Because of their uncompromising pitch-black backgrounds, far too many flash-lit photographs appear to have been taken in the middle of the night. With drama or action shots, such an effect is not unpleasant, high-lighting as it does the mammal or bird itself. But with shots of subjects like woodpeckers going

about their daily lives near their nests, a 'nocturnal' background is better illuminated by the use of a third flash.

While working in Rhodesia Peter Steyn showed us a method of flash photography that proved to be highly successful. This involved using flash to illuminate the bird, and daylight the background. For example a crested barbet, a bird rather like a woodpecker, was nesting in a hole in deep shadow though the distant background was strongly lit by sunlight. Using a Compur shutter in the lens, on this occasion on a Hasselblad, and therefore synchronised for the flash to fire at any speed, an exposure of 1/250th at f8 was given to correctly expose the background while the flash was positioned to give the correct exposure on the bird. Incidentally a simple method of working out the correct aperture to use with flash out of doors is to double the distance provided by the guide number for indoors. If, for instance, the flash is set up five feet from the subject outdoors, the aperture would be the same as for ten feet indoors, because guide numbers are calculated for use in a medium size room from which there will be reflection from walls and ceiling.

Slave Units

Though three flashes can be fired via a three-way connection to the camera boss, the tangle of wires can become a considerable nuisance. Besides which the longer the wires the greater the resistance and consequent reduction in power. It is for these reasons, rather than any others, that we make frequent use of slave units. A slave unit establishes each electronic flash set as a completely independent system. Instead of being connected to the camera, it is connected to a photo–electric–cell which fires the flash as a response to any other flash. Slave units cost only a few pounds, and in this context are used simply as triggering devices to avoid the use of lengths of cable.

Though highly useful in the field, we find that photography in zoos is simplified no end by eliminating wire connections between the photographer and his assistant. Each moves independently with a battery pack slung over one shoulder.

The photographer carries the main light attached to the side of the camera, while the assistant moves into position on the other side and at a slightly greater distance. The assistant simply points the slave unit in the direction of the expected flash, and the flash head at the subject.

Depending, once again, on the power of the flash unit used, the use of electronic flash as 'fill-in' will require a greater or smaller aperture to avoid 'ghosting'. The greater the amount of natural lighting, the smaller the aperture required will be to avoid this phenomenon. Put simply, the flash 'swamps' the natural light and only one image will appear on the film. If, however, the set is not sufficiently powerful, or the flash heads are not close enough to the subject, then a wider aperture will have to be used, thus increasing the chance of the image registered by the natural light differing from the image created by the flash.

When using flash, great care must be taken to remove all unsightly twigs and vegetation in the foreground. For though they appear as unsightly blurs in normal lighting, with flash they are highlighted and become prominently white. Having focused carefully, the use of flash and the consequent stopping down to f16 or f22 gives such a great depth of field that every result, irrespective of clouds, will be critically focused. Even if the bird never stops still for a moment while at the nest, we need not hesitate to make the exposure. A 1/500th sec. is quite sufficient to stop almost any terrestrial movement, and we are thus able to record interesting aspects of behaviour rather than wait for the bird's moment of complete stillness. So great is the 'stopping ability' of flash that with modern colour films crystal-sharp images, not only of the bird but also of its prey, can be obtained. From these results scientists can identify the species of insect or caterpillar on which the subject is feeding its young, thus adding to our knowledge of the species and its place in nature.

Birds take little notice of intermittent flashes. At first they may look round, but before long they ignore them completely, though the photographer who finds a subject that does not accept flash must be prepared to withdraw and give up

completely if it cannot be worked with the available natural lighting.

Flash in the Dark

With nocturnal or cave-dwelling subjects the same rules apply, except that the chance of ghosting is eliminated because there is only one light source. Here, too, we use two flash heads though perhaps at a slightly longer range. One important difference revolves around the difficulty of focusing at night, and for this reason we prefer to arrive at the hide well before dark. Even then, in the growing dusk, sharp focusing can be difficult. We use an illuminated opaque material held in position by an assistant, but in an emergency a lighted match will do.

A torch, such as those used by miners on their helmets, is a most useful tool for focusing in the dark. We have a lightweight one that is attached to an elastic head-band and powered by batteries that fit into a pocket. It has proved extremely valuable over many years, and is particularly useful during nocturnal photographic preparations of equipment. We have, however, used it to focus on owls that have stayed perfectly still and allowed us to focus and compose our picture as we would with a diurnal subject. The flash, of course, completely swamps the comparatively dull illumination provided by the torch.

Many nocturnal birds approach their nest very quietly and the photographer should be alert to the opportunity when it is presented. Some owls, in particular, visit the nest very infrequently, and to miss an opportunity of a shot will only increase the length of time that must be spent in the invariably cold and uncomfortable hide.

Similar techniques apply to the photography of mammals after dark though there are some important differences. With badgers, for example, it is as well to position lamps not only for their illuminative qualities, but also with a mind to their safety. The legs of lightweight tripods should be pushed securely into the ground and it is a good idea to attach lamps to trees if at all possible. Unlike birds, badgers are slow moving

animals and may not, therefore, trigger a photo-electric-cell as will a fast moving object. For this reason it becomes even more important to work on a moonlit night. It is quite possible, as we have already stated, to get badgers accustomed to floodlighting over a period of time though, of course, this will require a mains electricity supply nearby. If mains current is unavailable, or you prefer to work with flash on dark nights, the use of infra-red lighting is useful.

Infra-red lamps throw out light that is quite invisible both to the subject and ourselves. Fortunately we can use a converter tube to look through and see the images that are otherwise invisible. Image converters are battery operated and have been used by many photographers on nocturnal birds and mammals. But a torch, or any other form of artificial light, can be used to aid focusing provided that the subject is introduced to it gradually.

Action-freezing Flash

As a fill-in where natural light is insufficient, and in the photography of nocturnal subjects, electronic flash of the normal commercially available types is perfectly adequate. It is action shots that demand something more in the way of power and speed, and it is in this area that electronic flash really comes into its own. Short duration flashes of up to 1/10,000,000th sec. can be achieved from mains powered sets, but there is always a danger that such short flashes will fail to register on the film—a danger known as reciprocity failure. Doubtless even these sets will eventually be produced commercially, but at present they must be built to order by a competent electronic engineer.

Using flashes of such short duration on small, highly mobile subjects like flying birds involves the use of a photo-electric-cell automatic trip device set up across the bird's flight path. Most birds like to perch on their way to their nest and have a look around to see that no danger threatens before dropping down to feed their young. With many nests a wide choice of such perches is available and the photographer may well find

that having set up hide and equipment at one the birds will start to use another. Careful watching beforehand will show which perch they prefer and which are the secondary ones. If necessary the latter can then be removed, making the birds concentrate their attention solely on the one where the equipment is set up. In other cases it is possible to arrange a new perch that you introduce yourself, but do select a natural and pleasing one. Perches should be as near the nest as possible so that the bird has only a short distance to fly and will, therefore, be more likely to follow a narrow predetermined path.

The hide is positioned so that the camera can be focused at a point along this path. Flash heads are set up and the photo-electric beam positioned in such a way that the bird will cut it as it flies from perch to nest. To focus on the correct spot in space, a piece of string is held between the lamp unit and the photo-electric-cell exactly along the line where the beam will be when it is switched on. At the most likely spot on the string a piece of paper, preferably with writing or a distinct pattern, can be folded or clipped to act as a focusing card.

The same techniques can be applied to the bird as it comes in to land at the perch. But here the difficulty is knowing from which direction the subject will arrive. Fortunately, a great many birds use a well defined route, and with a little thought other approaches can be discouraged by removing other perches and establishing a prominent second perch some distance from the one overlooking the nest.

Nests are undoubtedly the best sites to work for shots of birds in flight but we have obtained equally good results, though with not the same definite choice of subject, at bird tables. As at their nest, most birds like to perch and see that the coast is clear before feeding, and a perch established a few feet and a little above a bird-table will be readily used (see Chapter 3 on Bird Photography). In this case the lamp unit is attached some distance below the perch looking up at the photo-electric-cell placed on the roof of the bird table, and forming a diagonal line through which the bird will invariably pass. Setting this outfit up just outside a window in the garden has many advantages to the immobile photographer who merely

has to wind on the camera shutter from time to time. It may also provide an end result of scores of photographs of house sparrows in flight.

To obtain the required speed of flash a fairly powerful set is required, but light out-put is even more important to ensure an adequate depth of field at such speeds. Even very small birds like tits measure six inches across the spread wings and both wings are required to be in focus.

Choice of Sets

We have heard a lot recently about computerised electronic flash sets. In the words of the sales brochures they eliminate the need for detailed light value calculations and time-wasting exposure settings. A photo-electric-cell within the flash head measures the distance from the subject automatically and then throws out sufficient light to illuminate it perfectly. With this equipment the problem of over- and under-exposed photographs within the range of the set (i.e., 2–13 feet or 2–23 feet depending on the power) are eliminated. In fact the closer the subject the shorter the duration of the flash. With the more powerful sets, like the Rollei Strobomatics, the flash lasts only 1/50,000th sec. at two feet but this speed declines rapidly with increasing distance from the flash head. These sets can be switched to manual and used in the normal way giving flash durations of 1/500th–1/1000th sec.

With most of them there really seems to be little advantage over the normal manual set for the wildlife photographer who expects to work at a flash range of about four feet. The extremely high speeds have already been lost at this distance and to move closer is to court disaster via non-cooperation on the part of the subject.

In its simplest terms what happens is that the set is geared to provide a flash of about 1/1000th sec. Having measured the distance from the subject the photo-electric-cell then cuts out a proportion of the flash, reducing not only its duration but also, of course, its power. If, say, the 1/1000th sec. flash is of 400

joules at long range it may be reduced to as little as 50 joules at really close range. And although one may obtain a flash as short as 1/4000th sec. at 1 to 1½ feet, because of loss of power the lens will have to be opened up to perhaps f4 or f8 with consequent decline in the depth of focus. Clearly this will not be sufficient for bird, and particularly flight, photography.

The choice of set then depends very much on what it is required to photograph, together with the characteristics of the camera. If small flowers and insects are to be taken *in situ* then flash heads will probably be fired only five or six inches from the subject. The illumination will be great and it will be necessary to stop down to f22 or even f32 to obtain a correct exposure, depending on the power of the flash. While these small apertures give an excellent depth of field not every camera boasts them. It is necessary, therefore, to check the power of a set at the range likely to be used against the characteristics of the camera before choosing it. It is, of course, always possible to reduce the power of a larger set by covering the flash heads with a handkerchief or some other material.

For such close-up work quite small sets are adequate. Many fix to the top of the camera via an accessory shoe, though an attachment that allows the flash head to be tilted backwards and forwards, and thus downwards onto really close-up subjects is required.

Ring flashes are extremely useful in the field of close-up photography because they eliminate shadows completely. The circular tube fits round the lens and there are even special tubes available for use with wide angle lenses—down to 28mm on the 35mm format. A variety of types are available to be used directly from the mains, from high voltage disposable batteries, from rechargeable batteries, and from the normal more powerful sets favoured by the general wildlife photographer.

For normal bird photography at the nest and of small mammals at bait or in captivity, we find the powerful commercial sets like the Mecablitz and the Braun ideal. With the latter set the battery allows about 200–300 flashes to be made from each charge with a recycling time of 3 to 5 seconds

shutter release

aperture control

lead to power pack

Figure 9. Ring flash in position on 115mm lens mounted on 35mm SLR with bellows

A cock bearded tit visits
his nest tucked away
among the debris at the
foot of the reeds. Vigorous
and unsightly 'gardening'
was necessary to open the
nest for photography.

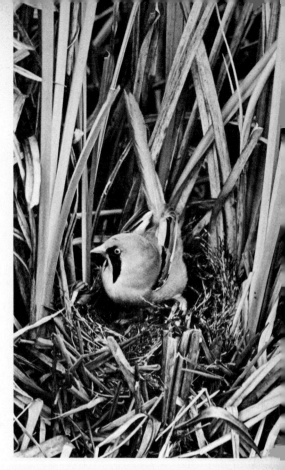

Flat-bottomed boats make
an ideal base for nests in
wet reed-beds or shallow
ponds. This one is in the
process of being moved
into position

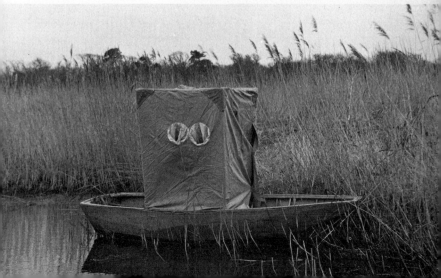

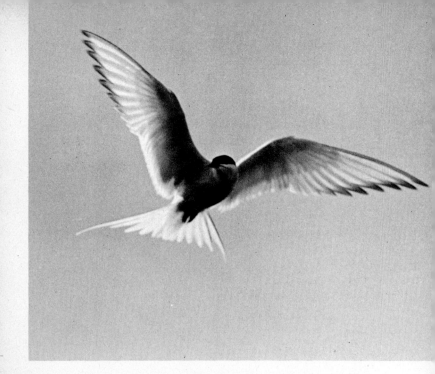

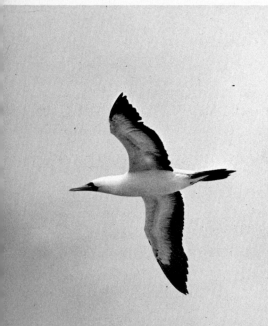

A 1/500th sec may be sufficient to stop the movement of an approaching bird – Arctic tern *(above)*. But the masked booby *(below)* required 1/1000th sec as it passed across the camera

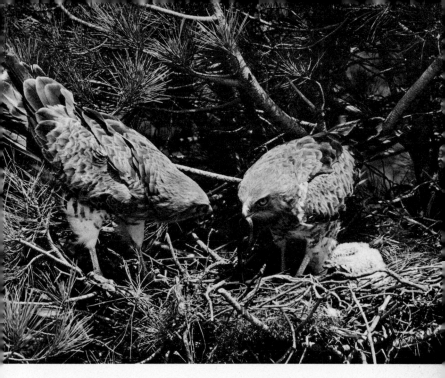

A pair of short-toed eagles at their nest among the dunes of the Coto Doñana, Spain. The pylon hide was improvised on site and connected to the nesting pine by a strut so that the two swayed in unison in the wind

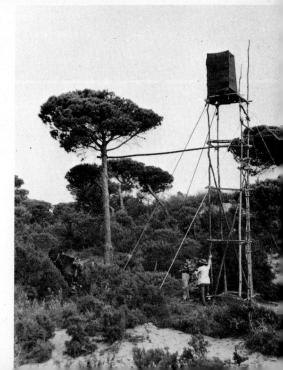

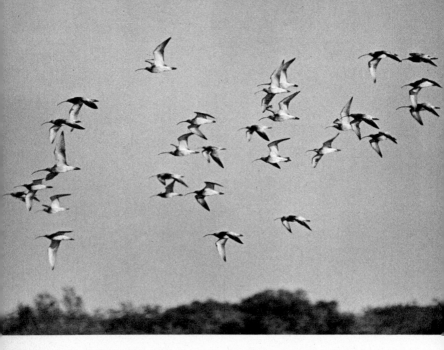

A flock of fast-flying curlew can only be 'stopped' by speeds of 1/1000th sec plus

The white-bellied sea eagle stands out from a background of small circles created by the mirror lens

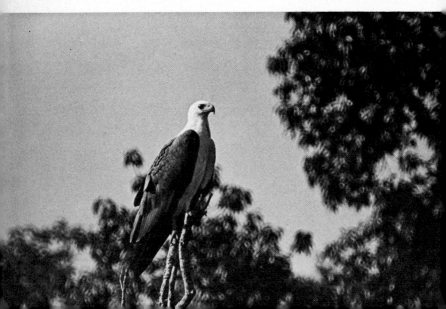

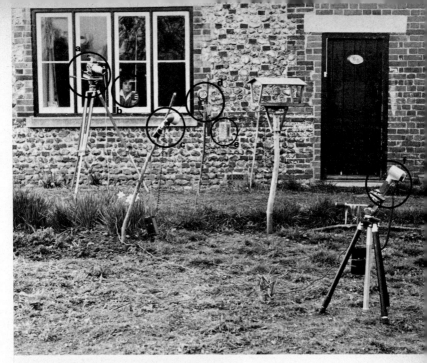

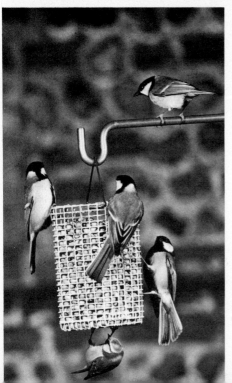

above: *The array of equipment that enabled the picture of great tits* (left) *to be taken consists of:* (a) *camera with motor drive and radio release;* (b) *radio transmitter release;* (c) *and* (d) *two flash heads to illuminate* (e) *the subject;* (f) *flash unit to illuminate the background.*

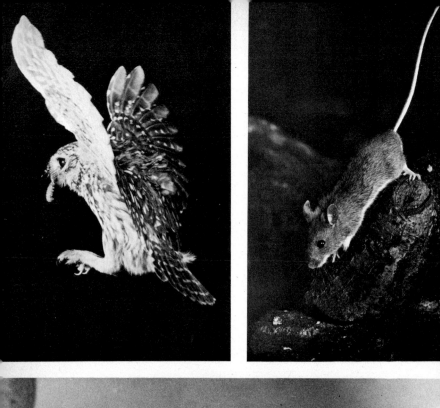

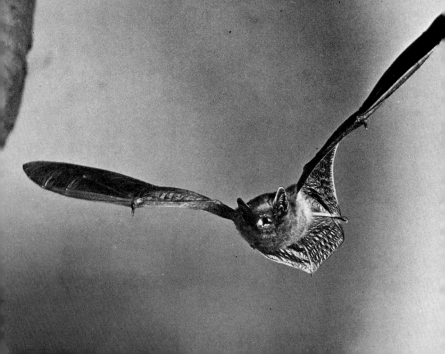

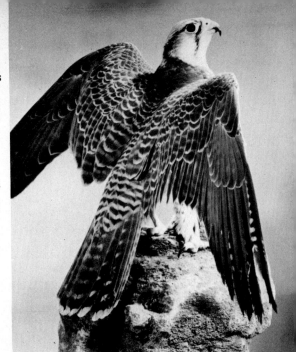

opposite: Three distinct uses of flash: to pick out a little owl as it arrives at its nest, to photograph a long-tailed field mouse in a vivarium, and to catch a captive pipistrelle bat in flight via a photo electric trip device

Portrait of a lanner falcon taken under controlled conditions in the 'studio-set' shown *(below)*. Equipment is the motor-driven Hasselblad ELM with three flashes and a flood used for focusing. *(S. C. Bisserot)*

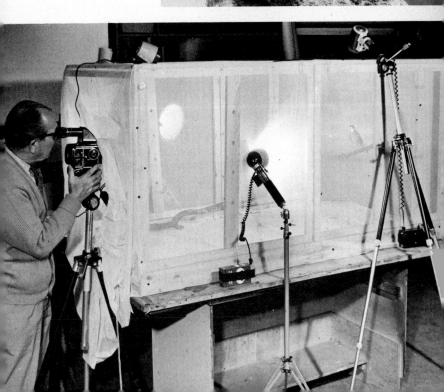

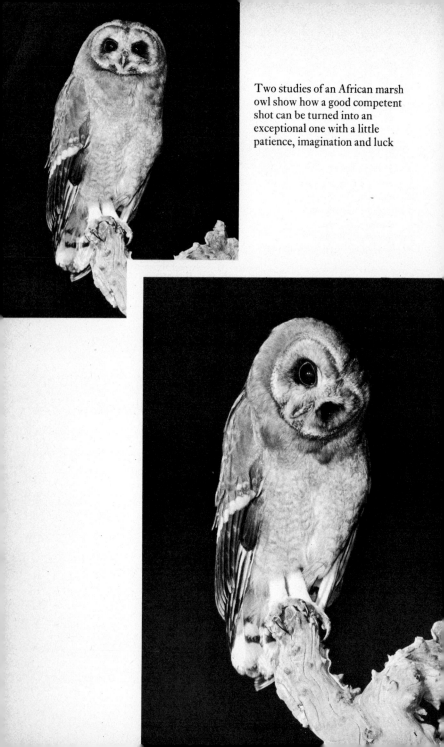

Two studies of an African marsh owl show how a good competent shot can be turned into an exceptional one with a little patience, imagination and luck

between each flash. This sort of capacity and recycling time, coupled with a power source of some six volts, should be adequate for most mammals and birds. Even four feet from the nest of a small bird the 1/1000th sec. flash will need no more than f16 to obtain a correct exposure, thus providing a very useful depth of field.

Even when equipped with the high capacity accumulator, a use can still be found for a dry battery set. We have two made by Honeywell of America. Basically the same as the re-chargeable outfit, it is powered by a 510 volt disposable battery that gives about 1000 flashes, has a shelf-life of a year, and costs as much as a medium priced light-meter. They are light and easy to use and we find our sets exceedingly valuable, particularly in out of the way sites (it's impossible to charge a battery from a camel), and with highly mobile photography where flash is essential but weight is at a premium. They are particularly useful in zoos where equipment has a habit of becoming heavier as one walks around the enclosures searching for a suitable subject.

A knowledge of electronics can be very useful particularly when, as happened to us once in Holland, our set went drastically wrong. It is, of course, also very useful when attempting to work out the solution to problems and set design. But such knowledge is seldom crucial to the taking of photographs.

Guide Numbers and Exposure

Guide numbers, like light meters, are good slaves but bad masters. Having obtained an appropriate flash set a period of trial, error and experiment is required to find out exactly what the effective power will be in different circumstances. Note taking is a crucial part of this process.

In all but the computerised sets the duration of the flash is a given and static factor, i.e., 1/500th to 1/1000th sec. depending on the particular make and model. But the variables remain to be calculated. The distance of the flash heads from the subject, the speed of the film, and the particular physical circumstances

have all to be taken into account in conjunction with the guide number of the set. The flash heads can be set at a distance that is appropriate to the subject and which the animal will tolerate —about four feet with a small bird. The speed of the film will be predetermined by choice, and this leaves only two variables, the aperture and the physical circumstances. The latter can vary from a small white-walled room, a similar large room, a large room with dark walls, outdoors in bright sunlight, outdoors in dull light to a pitch black night outdoors. Each will vary the amount of usable light that a given flash will produce and in turn increase or decrease the aperature required.

Though it is usual to allow one to two extra stops for flash photography outside even in good daylight, the subject must be explored by each photographer for himself. If the resulting aperture does not give the required depth of focus then the flash heads can be moved closer, a second set can be used, or the photographer can use a faster film. Whatever the outcome, the frequent user of electronic flash will soon know what is required in a variety of circumstances without even having to bother with elaborate calculations.

5 Zoo and Studio Photography

Wildlife photography can clearly be defined as photography of something that has life and is wild, and there will be purists who will feel that zoo and studio photography should have no place in this book. The fact that animals are 'controlled' does not mean that they are not wild. Indeed the tamest animals and the easiest subjects we have come across have been on remote islands, like the Galapagos where the wildlife photographer is embarrassed by the wealth of subjects and the closeness of approach that they allow. It could equally be argued that photographing a bird at its nest or a mammal at bait is to 'control' it. 'Wild' in our view does not mean either ferocious or timid, it is simply a word that we use to pick out a particular category of animals—but this borders on the philosophical and is simply intended to prompt the purist into further self-analysis.

'Controlled' photography of wildlife is a technique on its own involving different skills, different criteria of appraisal and often different subject matter. In many parts of the world the surviving mammals are predominantly nocturnal. In Australia, for instance, many of the large diurnal kangaroos and wallabies still exist, but the majority of species like the various marsupial mice and rats, the sugar glider, tiger cat, possums and other medium-sized mammals are all nocturnal and, therefore, very difficult to photograph. Unlike nocturnal birds, such as owls, they do not usually return to a regular nest to feed their young but carry them along with them. It may be possible to tempt them to bait but the chances of a successful series of pictures by this method are very slim, and the would-be small mammal photographer would be well advised to think in terms of controlled subjects.

There are countries in the world that are far richer than Australia in large diurnal mammals, though almost everywhere man has done his very best to eliminate these subjects before photographers can get their lenses to bear on them. The great plains animals of East Africa are the most obvious example, but seals at their rookeries and caribou on their migrations are two other wildlife spectaculars that any photographer would be delighted to work. But even here among the game and Arctic herds there are many smaller animals that, because of their nocturnal habits, are seldom seen let alone photographed.

Likewise animals that live in really dense jungles, and often in the tree tops at that, provide not a serious challenge so much as a virtually impossible task. The smaller mammals of the Amazon jungle and the Congo forests would not be photographed at all and the public would have only the vaguest idea, via paintings, as to what they looked like, were it not for controlled photography. There are subjects that are so rare that the only way of getting any picture at all is in a zoo. One could cite the Arabian oryx—chasing the deserts of the Middle East for 'wild' photographs of this animal would not only be a tremendous undertaking but ought to be discouraged anyway in view of the species' rarity, and the risk of harming it.

Having said all that we must stress that the subject matter is very often quite different from that of general wildlife photography. Either the subject is photographed controlled or it is not photographed at all—it is a simple choice. There are also different methods of appraising the controlled shot. Sharper results are demanded and an artistic quality that often involves considerably higher photographic skills and knowledge of equipment. Though anyone with a Box-Brownie can get a picture of an elephant at a zoo, it requires considerably more skill to get an interesting and acceptable picture of that animal under these conditions without a hideous and intruding background. Such pictures ought to be judged by different criteria from those taken wild and free.

Zoo Photography

There are some eight hundred zoos in the world, of which more than a hundred are in Britain. The latter are visited by 15 million people annually, many of whom take cameras with them. *The Penguin Guide to British Zoos* by Schomberg, and *Wildlife '74–'76* by Robins and Radford, are excellent starting points.

Zoos vary enormously. Some are open areas with huge enclosures that almost pose as many problems, perhaps more, as photographing in the game parks where the animals are found 'naturally'. Others have animals so crammed together in tiny cages that photography is almost impossible. Some of these smaller zoos are badly managed and the condition of the animals is so pitiful that one would not be inspired to take a picture at all. The principal criterion is the condition of the animal—is its fur sleek and glossy, or dull and matted; are the bird's feathers in good condition or bedraggled?

Animals and the Backgrounds

In general, though the major problem with zoo photography is the enclosure itself, for though one should not try to pass off a controlled shot as wild and free, a background that is sympathetic is essential. The animal should look natural even if it is not. Zoos, of course, are places dominated by bars and wire, though many progressive zoos have spent a great deal of money on imaginatively converting their enclosures to the moat-barrier system particularly for the larger animals. Basle, Stuttgart, San Diego, Hamburg and London zoos, to name but a few, have all gone varying distances in this direction. The 'safari parks', though criticised in some quarters, offer large animals in drive-through enclosures that are very enjoyable to photograph. Many zoos have, quite understandably, concentrated on the larger mammals and primates and small mammals are still more often found in wire cages. Though here too an injection of cash can convert a series of nineteenth century cages into glass fronted displays that are considerably easier to work. The Charles Clore Small Mammal House at London

Zoo is an excellent example of modern methods of displaying such animals.

The zoo photographic problem centres then around bars or wire at the front of the cage and unsightly, often white-washed brick wall, backgrounds. As a result the first instruction to the would-be zoo photographer is to research his zoos. There is absolutely no point in wasting time on poor specimens in unsightly conditions. Look for happy animals with life in them that are well housed and where the background, if not 'natural', is at least not too unsightly. A background can, of course, be blurred out provided the subject is some distance away from it by using an aperture with a sufficiently narrow depth of field to include the subject and blur everything else behind. The same result can be achieved by carefully choosing a low viewpoint or an acute angle from which to shoot.

Similarly bars, or wire, in the foreground can be blurred into disappearing altogether by placing the camera lens against them. One should, of course, avoid placing a bar directly in front of the lens. A word of caution, however—at all times obey warning notices displayed on cages, and in no circumstances climb over a barrier to get your lens closer to the bars or wire. Every year people are mauled by dangerous animals and frankly no picture is worth that risk. Besides which bars can easily be blurred out, even at a distance, by using a longer focus lens with a smaller depth of field, and adults have a responsibility to show children how to behave properly towards captive animals.

Firstly then choose your zoo with specific regard to the condition of the animals and the type of enclosures in which they are housed. Whipsnade and the commercial safari parks are excellent places for finding animals against natural back-grounds. Patience may well be needed, but the resulting shots will be so much more satisfying than those with brick walls or concrete as backgrounds. Even under the very worst conditions it is still possible to take head and shoulder portraits of animals that bring out the character of the subject in a way that would be difficult, if not impossible, in the wild. Tigers, for example, are now so rare in the wild that the photographer

must search the zoos for the right animal in the right conditions, and even then be prepared to come away with only a head shot or nothing at all for his pains—but there is always another day.

Small mammals, particularly those nocturnal species that are otherwise so difficult, are often housed in small cages where the only possible photographic technique is to use electronic flash. In the Clore House, for example, the animals are kept behind glass in interiors that are too dark to work in any other way. Here the main problem is to position the flash heads in such a way as to eliminate reflection. Nevertheless two flashes are best, otherwise the animal may give a very dense and unsightly black shadow. The method that we adopt is to fix one flash head to the left hand side of the camera and push both head and lens against the glass. Then an assistant holds a second flash head two or three feet away, if space permits, otherwise as far as possible to the right of the camera and a similar distance above it. To fire the second flash we use a slave-unit, a photo-electric cell, so that our assistant is not tied to us by wiring which is so easy to trip over—see Chapter 4 on Flash. This technique effectively eliminates reflection and at the same time allows the use of quite short focal length lenses with a good depth of field. The use of powerful flash gives a result that is crisp and of great fineness of detail. Unfortunately most zoos do not allow the use of tripods and an assistant to hold the second flash is a great help.

While on this subject it is absolutely crucial to find out what rules the zoo has about photography. Most of them do not mind, but some do and it will avoid unpleasantness to inquire of a keeper beforehand rather than be told later. Besides which most keepers are interested in their animals and like to show them off. If you express approval of their condition and a desire to photograph them keepers can be exceedingly helpful. Provided you look serious and sound interested a keeper might open cages and act as your assistant if he is not too busy. In such cases an adequate tip is a fair reward and leaves the opportunity open to return and call upon his services once more. But in any case do find out about rules before starting work.

Above everything else in zoo photography the position of the animal is paramount. You may want a picture, let us say, of an ocelot, but when you arrive this animal is asleep curled up in a corner, or perhaps pressed right up against an unsightly background, or walking to and fro right at the front of the enclosure. In these circumstances distraction antics and noises are seldom of any use because the animal is treated to this sort of human aberration all day and usually takes it for what it is—an irrelevance. It is far better to go away and work another better placed subject and try again later, by which time it may well have moved to a more convenient position. At all times seek for perfection, look for the ideal position and be prepared to wait or even give up altogether if, say, the glass is dirty on the inside.

Cameras and Equipment

Equipment for zoo photography is much the same as for other wildlife subjects. On the 35mm format the most useful lenses are the 50mm, 135mm and 180mm with just occasionally the 250mm or 300mm at large zoos like Whipsnade. On the $2\frac{1}{4}''$ square the 150mm and the 250mm with the 80mm for subjects that can be approached very closely, such as the smaller reptiles, are appropriate. In the latter case it is sometimes even necessary to use a close-up attachment or an extension tube.

Whatever results are achieved at a zoo one is seldom fully satisfied. Even under these conditions a 100 per cent perfect result is seldom obtained and the challenge is a continuing one. Perhaps there is too much unnatural background, perhaps the animal shows fear, perhaps the result does not quite capture its character. Whatever the criticism, one will be forced to return to try again for the very perfection that one knows is a possibility under these conditions. Let there be no doubt about it, zoo photography is far from easy.

Having taken a picture, let us say, of a chimpanzee and obtained a perfect head and shoulder portrait, the photographer then wants to try for a shot of the whole animal. Then perhaps of a pair indulging in an interesting piece of behaviour. For

difficult as it is to get a picture at all in the wild, the difficulties of obtaining behavioural sequences require a lifetime of dedication to solve. This does not mean that the difficult should not be attempted in wild and free conditions, but that for scientific and other purposes zoo shots of animals like primates are useful. We cannot all emulate Jane Goodall and Hugo van Lawick whose quite remarkable work on chimpanzees and wild dogs makes breathtaking reading and spectacular photography. Their work, taken wild and free in Africa, was achieved only after years of patient effort.

Most animals are better at one time of the year or another and the serious zoo photographer will get to know his animals and the people who look after them. Birds moult, snakes shed their skins, mammals breed and have youngsters. There are times to go and times when it is better to stay away. The keeper is the expert: cultivate a good keeper and you will save a lot of time and film. In some cases a relationship can be established in which the photographer and the keeper almost become a photographic team. In these happy circumstances not only is access to the cages available but special foods and artificial backgrounds can be utilised. We have a rolled material background with different habitats painted on that, with differing degrees of position or focus, can supply the impression of a savanna scene, a marsh or reed bed or a tropical jungle. In this way we are able to place the animal in its 'natural' habitat—but we never, under any circumstances, try to pass such pictures off as wild and free. The use of the background is simply an attempt to make a more pleasant and accurate picture.

Parks and Pets

Parks are effectively large scale pens for somewhat more tame and easily controlled animals like deer. Many large estates have deer parks where the animals are to all intents and purposes wild and free and yet confined, easy to find and easy to watch. Red and fallow deer are particularly common in parks and can be approached to within photographic range without much

difficulty. Not that a close approach is without its dangers. A red deer stag in full eight-point regalia in the autumn rutting season is a formidable animal, and not one to be trifled with. His horns are an aggressive weapon and though he will ignore people at a distance, approaches to within 50 yards should be undertaken with great care.

Nevertheless, these herds of animals do provide opportunities for fine portraits, and in the rutting season one may obtain exciting chances to photograph the aggressive head-up braying posture and fighting between two stags. The best equipment for this is the 35mm with the 300mm lens supported by a shoulder stock, or a car window, which allows a sufficiently close approach without venturing too far into the danger zone. Of course such pictures can be taken in the free and wild state. Personally we feel that the satisfaction obtained from a 'park' shot as against setting oneself against the truly wild animal is nowhere near as great, but then one must expect a much higher standard of excellence from 'park' work.

While 'park' animals are seldom dangerous they are still wary, but 'pets' have usually lost everything that makes them 'wild'. They do, of course, provide another opportunity for the photographer but one in which he almost takes on the role of movie-director. To get a wild fox carrying off a chicken is a difficult task and one that needs a great deal of planning, preparation and patience. To get a pet fox to pose in a similar manner will be somewhat simpler and provide a more dramatic result. No doubt the thrill of the vigil, the excitement of pitting one's wits against a cunning wild animal, and the satisfaction at achieving a successful result disappear, but judged purely on the finished product it is difficult to see how in many cases the free and wild photograph can compete.

People have some strange pets. We know of families with foxes, badgers, hedgehogs, lions, cheetahs, monkeys, apes, in fact almost everything that can be tamed and house-trained. Even more people keep birds, and while it is good fun and practice to obtain pictures of captive budgerigars they are as nothing compared with the real thing—vast flocks of green and yellow birds round some Australian water hole. Falcons and

birds of prey are kept by many people as pets, as well as by falconers. Trained falcons can make excellent subjects, not only because they are so well looked after and kept in such fine condition, but also because they will allow an approach at times where any self-respecting free hawk would be off in a flash.

Try as one may, it would be very difficult to get a wild picture of a peregrine mantling its prey, or of a short-toed eagle battling with a snake. Falconers' birds will allow such pictures as well as the perfect head and shoulders that is so difficult to get in the field. Flight pictures too are easier with a trained bird that will wheel overhead to give several chances of a successful shot, but the result will invariably be spoilt by unsightly trailing jesses.

With pets as with parks and zoos, the fact that shots can be taken under these conditions should not be a substitute or an excuse for not trying for wild and free action.

Waiting at a fox or badger sett, for instance, requires careful preparation and a knowledge of the individual animals concerned. Over a period of time Eric Ashby got a particular family of badgers so used to his presence that he can sit quietly nearby as they go about their nightly business, while Ernest Neal even got his badgers accustomed to brilliant floodlight to film them at night.

Studios

Discussion of zoos and particularly access to cages and the use of artificial backgrounds takes us into the realm of the photographic studio. Most photographers, other than wildlife specialists, prefer their studio where they have complete control over the conditions under which they work and where all the multifarious pieces of equipment and apparatus are at hand.

Wildlife photography in studios falls into two rough categories—highly dramatic pictures of subjects that are straightforward enough to photograph, if with less impact, in the wild; and pictures of subjects that are well nigh impossible in natural circumstances. In the first category we think of Ron

Austing's kingfisher underwater, while the second includes photography of small mammals like the pygmy shrew.

Studio Drama

Ron Austing is an American photographer who set out to get pictures of birds in positions that they had never been taken in before, either in the air or underwater. He wanted the kingfisher diving into the water, catching its prey and returning to a perch. His results are not only dramatic but also provide interesting insights into the behaviour of this bird. But perhaps his most outstanding shot, and one for which he would go down in the annals of wildlife photography whether he ever took another photograph or not, is the picture of an owl catching its prey. It has been reproduced many times throughout the world and shows a saw-whet owl with wings spread back and talons reaching forward for a mouse on a post. Every feather of the bird and every hair of the mouse is perfectly sharp. It is a highly dramatic picture and one that took a great deal of patience to achieve.

Anyone foolish enough to think that they could take the same photograph given Ron's equipment would be in for a nasty shock. It takes time and patience to take animal photographs, but to take the Ron Austing action shots requires months and months of rehearsal before it comes right and he gets what he wants. The bird must become accustomed to the studio and to the photographer himself. It may have to learn to obey instructions and do certain things to order, but above all it must be happy and healthy with no unsightly injuries or broken feathers as a result of being confined.

Most of Ron Austing's pictures are taken by an elaborate battery of electronic flash units giving a very bright, short duration flash triggered by a photo-electric cell. As the bird flies or dives into the required position it breaks the beam and triggers the camera into taking its own portrait. In this way Ron has obtained a series of shots of birds flying dramatically at the camera though in fact they are flying at Ron's bidding to a perch just to one side of the lens.

To enter Ron Austing's studio is to enter a hyper modern photographic workshop. Almost every device is connected up with wires to another and there appear to be so many tripods that one wonders how on earth the subject was ever persuaded to perform its task between them. The answer is time and patience and endless hard work for a result that is both dramatic and unusual.

To get his picture of the kingfisher Ron Austing had to construct a special pond in his studio, stock it with fish, make the surroundings look quite natural, and then persuade a captive kingfisher to feed. Months and months of work were involved, and doubtless hundreds of exposures were made before he obtained the pictures that were eventually published. It can be a considerable saving to start such sessions using the cheaper black and white film, changing to colour only when the subject has eventually got it right.

Studio Perfection

Other wildlife photographers prefer to work in studios, not to obtain the dramatic but simply because they want the sheer perfection that, they feel, can only be obtained in this way. In this respect one can contrast the pictures taken of wild and free hummingbirds with those taken in studios by Crawford H. Greenewalt and Walter Scheithauer. Here the subject is so small and elusive that a close-up approach is a necessity. But at the same time these superb little birds only come into their own in flight, where the brilliant iridescent colours show at their best. Thus the problem is a mixture of close-up photography and action shooting of a highly mobile animal that can only really be achieved under studio conditions.

Greenewalt used a portable studio on his travels in South America to obtain his unique pictures of hummingbirds. Having trapped the bird it was then placed inside the studio where food, in the form either of a feeder or flowers, was provided. He then proceeded to take pictures using an electronic flash giving an effective exposure in the region of 1/30,000th of a second. Such fast speeds are, of course,

required when the problem is to stop the wing-beats of a tiny hummer, but by doing so Greenewalt also showed that these birds can fly backwards and that when hovering their wings are completely reversed on the backward stroke. No technique other than high speed flash photography could have demonstrated this fact. Many of Greenewalt's pictures are works of art with both flower and bird being crystal sharp and beautifully composed. Scheithauer's flowers are so beautiful that they even rival the hummingbird itself in their brilliance.

It is for artistic reasons that other photographers have recently started working with quite common birds in studios. They are after the perfect portrait of a bird away from the nest against a background that is either 100 per cent authentic, or a plain colour so as not to intrude on the subject. Some go to elaborate lengths to obtain the right foliage for the bird to perch on. Other workers do not go to such lengths partly because they feel that a better picture results from a less definite background against which the subject stands out.

The Australian government commissioned Donald Trounson to photograph every species of bird in that country and he spent many months in the field, travelling that vast continent taking pictures in a portable studio. The technique involves catching the birds, placing them on an appropriate perch in the studio, adding a suitable background and working with electronic flash. Of course it is not simple. Few captive birds will sit still on a perch to await portraiture, though the darkening of the studio helps considerably. We cannot, however, think of any other method that would provide illustrations of such a large number of birds so quickly. Many of the species are being photographed for the very first time, and this in itself is a unique contribution to ornithology. Unphotographed species have, in the past, been illustrated by paintings where at best the artist has assumed that the structure of one bird so closely resembles another that it must stand and move in the same way, or at worst just guessed how it behaves. Trounson's portfolio will remedy this situation. The only alternatives to controlled photography are to work laboriously at nests season after season (we know of one South African bird

photographer who has done just this for the last ten years) or to work a 'wait and see' hide in a variety of situations that birds will come to.

There is clearly an opportunity here for similar studies in other parts of the world like South America and Asia, where photographs of the avifauna are so few and where working many birds is so very difficult. A tropical jungle is, however, a photographer's nightmare. Not only are these regions so difficult of access but condensation on optics and even short-circuiting of electronic equipment can occur very easily. If nothing else this technique would add considerably to the knowledge of identification of birds in these regions, and with a growing demand from museums for reference material other than the traditional cabinet skin, studio photography may have an important rôle to play in the future development of ornithology.

As yet it is a young art whose techniques are still evolving. The essentials are high speed flash; a portable studio in which to confine the subject with the facility to change the background quickly and simply, with a hole for the lens while the photographer remains out of sight, and a correctly positioned perch that is itself easily inter-changeable. Certainly there is no point in hundreds of pictures of different birds all on the same perch and against the same background. But given these ingredients the prospective portable studio photographer is going to have to take many shots before he gets it right. Trial and error and copious notes are the answers to problems like: which lens? What distance? What distance is sufficient between the subject and the background to give the slightly blurred effect that is required? What power flash? What aperture and speed? These and other problems have to be solved for oneself.

There is finally a legal problem. You cannot trap a British bird, play with it for a few hours and then let it go without breaking the law. A licence is required from the Nature Conservancy Council to be allowed to trap birds for any purpose, including ringing, and these are not just granted on demand but for a stated purpose backed by references. Doubtless the situation is similar in other countries, but even

where no such laws exist it would be unwise to give local people the idea of adding to their diet by demonstrating the effectiveness of the modern mist net. Fortunately these nets can be legally purchased in this country only from the British Trust for Ornithology by accredited bird ringers, and anyone anticipating trying this form of work would be well advised to start photographing his neighbour's budgerigar before he bothers the Trust for permission.

Bats in the Studio

The studio, not portable but the fully equipped permanent type, is also the best place to obtain pictures of bats in flight. The technique involves·high speed flash and a photo-electric cell trip. Here again one is in an area of trial and error where only guide-lines can be laid down to help along the way. The camera is triggered by the photo-electric trip which also fires the high speed flash in synchronisation. The difficulty is to get the bat to break the beam and take its own picture.

Bats have a nasty habit of disappearing behind tables, down the backs of chairs and behind curtains and books, and an important first step is to clear the room of everything except essential equipment. Then block every opening to the room including the windows, the gap under the door and, most important, the chimney. The chances of getting the picture you want instantly, first time are so remote that it seems a pity to let your subject go each time you try for an exposure and have to trek to the nearest bat roost for a new animal. Even indoors a butterfly net is a useful aid to recapture.

Having set up the equipment everything depends on the release, and here begins the great trial and error process. We have found that the pipistrelle bat, for example, flies almost directly upwards on being released from the palm of the hand. If held about 12 inches below the beam and a little behind, it has sufficient time to complete one downward beat of the wings and raise them for the second before rising to the height of the beam. This pose with wings spread is very dramatic, but the bat cuts the beam in about only one in ten attempts and even

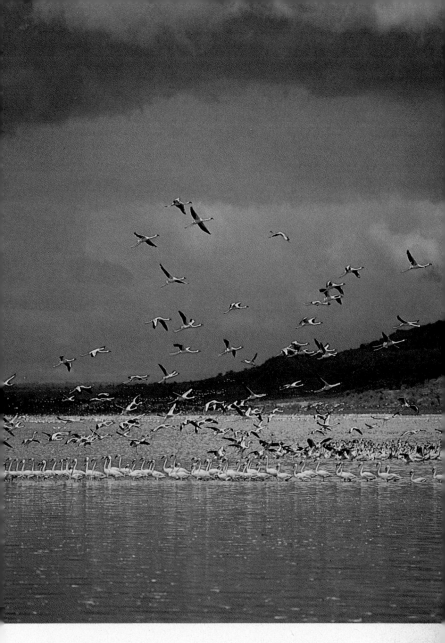

A tropical storm adds a touch of drama to what has been described as the greatest bird spectacle on earth: the flamingoes of Lake Nakuru, Kenya

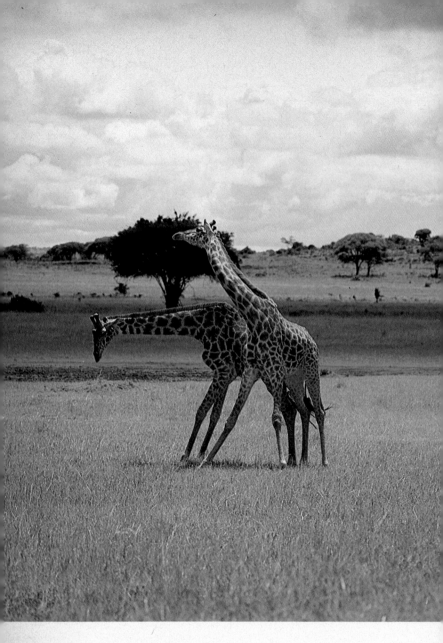

Giraffes caught fighting in Nairobi National Park, Kenya. Because of its unique shape and stature this animal poses a real problem to photographers searching for a fresh viewpoint

The marine iguanas of the Galapagos Islands are both interesting and photo-genic. Here the problem is not how to approach the subject but how to evoke their unique presence without degrading their tameness

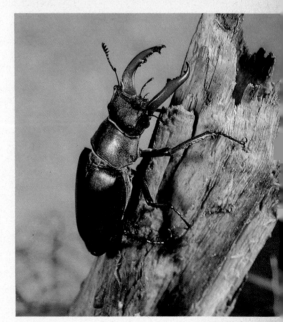

A stag beetle collected in the New Forest and photographed under controlled conditions. The avoidance of reflection on the creature's shell is a major problem

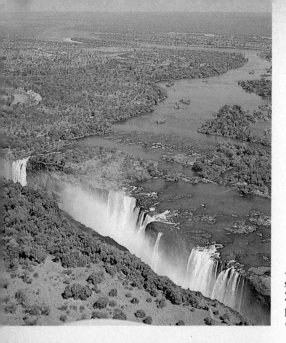

Aerials make effective habitat shots. Victoria Falls and the Zambesi River taken through perspex at 1/500th sec to eliminate aircraft shake

The orange lily *(Lilium bulbiferum)* shows to perfection the value of colour in flower photography

then there is no guarantee as to the type of picture that will be obtained. The horseshoe bat, in contrast, flies off at an angle when released and most often does not cut the beam at all. And remember that before you try again you first have to catch your bat.

Small Animal Photography

From dramatic shots of bats in flight taken in the studio it is not far to general photography of small animals in and out of controlled conditions. Bats, for instance, can be photographed in their roosting caves by stealth and high speed flash under perfectly wild and free conditions. Having found your roost and set up your equipment you can approach the subject quite closely with the aid of a strong torch provided that you do not offend the bats by impinging on their major sense, i.e., hearing. Talking, stumbling, tripping and general noisiness is the greatest sin in bat photography. The torch once again will be used as a focusing aid before the exposure is made with the flash unit.

Frankly we prefer these hanging shots (we have of course had them printed upside down with the bat standing on his feet) to those shots of the bat's face staring over a piece of bark. Such pictures often allow a better portrait particularly showing the nose and ears that are so distinctive with the different species, but similar results can be obtained in daylight if the bat is placed (hung) from a prepared perch in front of your set up outfit. It is quite possible to photograph bats in flight in a wild and free state by setting up equipment including flash and photo-electric trip at the mouth of the roosting cave. The trip is placed across the mouth of the cave and the bat takes its own picture as it emerges.

With most small animals, however, the problem of obtaining a dramatic result does not arise, instead it is a matter of overcoming secretiveness and timidity. Almost without exception they are best worked with flash, not only because they are nocturnal but also because their small size makes a close approach essential and flash is necessary to obtain a satisfactory depth of field.

With medium-sized subjects that are slow moving, like the hedgehog, all that is required is to find the mammal—invariably wrapped up in a ball—set up your tripod and camera and settle down to wait. Eventually it will unroll and allow its portrait to be taken, but remember to use a faster shutter speed that you would for a non-wildlife slow moving subject because of the animal's rapid reaction to the click of the shutter. If, of course, you use high speed flash that alone will stop movement.

Animals smaller than the hedgehog divide roughly into those that can be taken *in situ*, such as the reptiles and amphibians, and those that need controlling like most small mammals, though even here some photographers have managed to photograph many small mammals by patient watching and baiting in the wild. Rodents, however, are best worked in captivity and the first problem is to obtain your subject. Clearly the animal must be caught alive and unharmed and the usual method is to set a Longworth or similar box trap that is baited and self-triggering. The trap is best placed on a 'run'—a path used regularly by the animal often marked by a small hole in the grass. Having caught your subject it should be put back into a controlled piece of nature that you have specially created for it, and be returned whence it came once you have finished with it.

This controlled environment was formerly known as a vivarium—still as suitable a name as any. It consists of a framework of wooden base and sides with a glass front and back so that it can be seen through completely. Two separate structures for different sized animals is ideal, with one 30 inches by 9 inches and the other 12 inches by 6 inches. These should be adequate to cope with most of the likely subjects. The pieces of glass fit into grooves in the sides and can be moved backwards and forwards according to the size of the animal that is to be housed, giving it just sufficient room to turn round without allowing it to pass out of a very narrow band of focus. Do not forget to cover the top with a lid. The vivarium is usually furnished with a layer of soil, appropriate vegetation and an attractive perch in the form of a twig or rock

that is pushed into the soil. This use of soil makes it easy to change the perch and vegetation and prevent monotony of

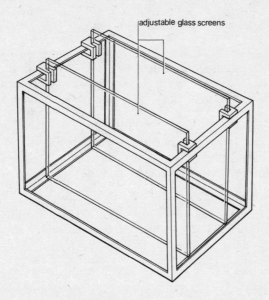

adjustable glass screens

Figure 10. Vivarium : size depends on the subject to be photographed.

surroundings in your pictures. An appropriate background can be set up behind the glass at a sufficient distance to appear out of focus but not invisible in the finished result.

When first introduced to the vivarium a freshly caught rodent will spend considerable time investigating every corner of its new home, and it is as well to darken the room for a while until it settles down. When taking pictures remain out of sight at all times. This can be arranged by photographing through a hole in a hanging blanket or curtain similarly to the way a bird photographer works from his hide. In fact the vivarium must either be covered while the equipment is set up or better still set up before the animal is introduced to it, for usually one

sight of the photographer is quite sufficient to set the beast into a frenzy of activity.

Having established the animal in its temporary home and accustomed it to a restricted life, you will probably find that it takes quite readily to the perch that you have arranged. There should be just sufficient light in the room so that you can see to compose your picture and focus. Once you have exposed, the mammal will probably panic at the noise and intense flash of light, but it will recover completely within a few minutes and you can then try again. Certainly, flashes of light are more likely to be acceptable than the scent or sight of the photographer.

As to the lighting the problem, as with working zoo animals behind glass, is one of overcoming reflection. This time there are two glasses to deal with, and once more the two heads must be pressed right against the front of the vivarium avoiding reflection from the second glass by arranging them at a considerable angle. It may be possible to place one light over-head. The camera should be positioned with one flash head near at hand and the other to one side and above. To test for reflection use a torch moved around in potential head positions while you view through the camera. With a powerful flash set at such close quarters it may be possible to stop down to f32 and obtain a good depth of field, but if the camera will not stop down sufficiently, power can be reduced and the light softened by placing handkerchiefs over the flash heads.

The lens should allow as close an approach as possible so that the animal half fills the frame. We use the standard 50mm lens on the 35mm or 80mm on $2\frac{1}{4}''$ square format, with a close-up lens for all but the largest subjects. Of course, the special close-up lens and bellows attachment begin to come into their own here. The depth of focus should start just the far side of the front glass and extend to the rear glass if possible. The perch should be just slightly nearer the front than the rear.

Some animals, like the common shrew, feed quite freely in captivity whereas others are quite impossible to sustain and need to be returned to the wild soon after they are captured if they are to survive. It is as well to find out what your subject

favours and lay on a supply in case it can be persuaded to feed, thus prolonging its stay with you and the chances of a successful relationship. Water should be provided as well as moisture-containing foods such as fruit.

Some photographers prefer to work small mammals in a larger area than the vivarium, say in a corner of their studio, where the animal has plenty of room to sleep, hide and move around naturally. This is a lengthier process and one in which it is absolutely essential that the animal is happy and eating well. After a while it will begin to settle down and make a real home for itself in the corner. The first flashes will send it scurrying into hiding, but after a while it will become used to them and allow exposures to be made as it goes about its everyday living.

With all of these methods the difference between the competent, the good and the brilliant is one of care, preparation and imagination. Be prepared to work hard at backgrounds and environments to make them absolutely right for your subject. Choose your perch carefully and with great consideration following an extensive search in old woodlands. Try to introduce a bit of action by encouraging the animal to stand up, or in the case of a carnivore by feeding it on its natural food. Don't throw in everything you can think of, but do use imagination to make a better picture.

While many small active mammals need to be captured and photographed in the controlled conditions of a studio, no such steps are necessary for successful reptile and amphibian photography. Almost without exception they can be photographed where they are found or by transportation to a suitable site nearby. Like most small creatures snakes, frogs and toads try to escape but they move so slowly that re-catching is easy, especially when they are transported to an open area suitable for photography. The major photographic problem then resolves itself around persuading the creature to stay still long enough to obtain the picture.

Snakes are comparatively easy to work and the most difficult task is to find the subject in the first place. Heaths and commons are the best hunting grounds but do beware of adders. A

bite can be lethal and is at all times very unpleasant. Ensure that you know what you are looking for, and if you find an adder handle it with heavy workmen's gloves or with a stick. A knowledge of your animal and patience are the tools of success.

Having captured your subject the search for the right background will make the difference between a run-of-the-mill photograph, and one that is interesting and pleasing to the eye. A lichen-covered rock, or broken tree stump with moss makes an attractive picture in its own right—a picture that the addition of a snake can only enhance.

Of course, most animals, no matter how slow moving, are not going to wait for the photographer to set up his outfit or stay still long enough to allow their picture to be taken. They do, however, react very well to darkness, and it is a well tried and successful technique to drop a hat or a cardboard box over the subject in the place where it is required, while the photographer sets up his tripod and flash units. Most reptiles will settle down quite happily after a few minutes in the dark, and will stay more or less still when the cover is removed. With snakes there is always a good chance that having rolled themselves up into a ball their head will be facing the wrong way for photography. If so simply drop the hat back over the creature, more your equipment round to the other side and try again.

With animals like snakes it is quite possible to work really close with the 50mm lens on the 35mm camera, but at all times beware of the poisonous varieties. It is surprising how the photographer can get carried away looking through a viewfinder and become totally oblivious of his surroundings and the potential danger of the subject. If, for instance, you wish to obtain a close-up of the head of an adder to show the 'V' marking you would need to get within two to four inches if using the 50mm lens. It is therefore safer to use a 135mm from a greater distance.

It is not difficult to obtain pictures of frogs and toads free and wild where they are found, but almost every picture can be improved with a little time and effort. Perches are important with these small subjects, but photographs looking slightly down into a marshy pool have a distinctly authentic look about

them. Several photographers have created their own miniature pool with flourishing vegetation to get the control that they require, but there is no need to go to such lengths to get a shot, unless you intend to specialise on these subjects.

Frogs and toads pass through a complete change of form, and a series showing the evolution of spawn into tadpoles, and the tadpole into the frog is an excellent project. Unfortunately a really close approach at the spawn and tadpole stage is required taking us almost into the realm of photo-micrography, where a bellows becomes of great advantage. Heather Angel has specialised in this sort of photography and has achieved some really beautiful close-ups of small animals as well as fine resolution results of more purely medical subjects.

With frog-sized animals we make most use of the 135mm lens, with close-up attachments, on the 35mm format. Two flash heads and a tripod are strongly advised to obtain the depth of field that is required when working with telephoto lenses at such short ranges.

'Studio' Spectaculars

Among the pictures that illustrate every modern book on wildlife there are always some that are quite outstanding. Usually they are full of action with animals fighting, leaping, displaying, courting, feeding, or such like and one wonders how on earth they were obtained. Some, like pictures of red hartebeest fighting or the reactions of an elephant herd to the death of one of its members, are the result of good fortune on the part of the photographer by being in the right place at the right time, allied with technical excellence, a quick and intelligent eye, endless patience and the perseverence to spend long days and months in the field watching and waiting.

Others are more often controlled or set up in a studio. Just as it is possible to get pictures of bats in flight as described earlier, so one can get, say, a frog jumping with the aid of the photo-electric cell trip device. The work and skill in this case lies in setting up the equipment to achieve the desired result. Similarly dramatic and highly interesting pictures of a

chameleon catching a fly with its tongue fully extended can be obtained via a 'trip', though F. W. Bond achieved this in 1935 at the London Zoo using a $\frac{1}{4}$ plate camera, a 6 inch lens, and a manual shutter release.

Photography of woodpeckers, another group of animals with exceptionally long tongues, has demonstrated the way in which the tongue of these birds can search through the rotten bark of a tree for insect grubs hidden away in cavities beneath the surface. To achieve this Heinz Sielmann sawed through a rotten tree trunk and placed glass against a resulting section that boasted a good selection of grubs. A captive woodpecker was then encouraged to feed in a 'natural manner'. Such photographs are not only spectacular but extremely interesting to the serious ornithologist who cannot actually see woodpeckers feeding.

The feeding of the unique Galapagos woodpecker finch has been filmed by Alan and Joan Root in the same manner. This interesting little bird has adopted the niche that elsewhere would be occupied by the true woodpeckers, but has not evolved the long tongue of those species. To compensate it picks a thin twig or cactus spine and pokes this tool into likely holes in its search for food. When it extracts a grub it promptly drops the twig and eats the food.

Perhaps the most spectacular shots of all are feeding and fighting shots, where two animals are locked in combat, or the amazing ability of predators to swallow their prey is highlighted. Unfortunately it is often sheer commercialism that prompts the taking of high drama shots. The rewards of natural history photography are quite attractive enough to induce photographers with no interest in, or understanding of, the subject to venture into the field. They may commit glaring errors but these are seldom apparent to publishers who go more for picture drama than picture authenticity.

Nevertheless the value of the studio spectacular is not diminished by its abuse by a few photographers. As long as the results are not passed off as wild and free in a deliberate attempt to deceive, the use of spectaculars can only do good to the wildlife cause.

6　　　　　　　　Cinématography

Taking still photographs of wildlife seems superficially to be child's play compared with the difficulties that face the maker of wildlife movies. Whereas the photographer catches the subject at a particular moment of time, the cinématographer is searching for action that shows how the animal lives and fits into its environment. While the photographer concentrates all of his attention into the moment of shutter release, the cinématographer knows that at this point his problems have only just begun. He must involve himself in the scripting, shooting treatment and editing, as well as dubbing and commentary if he has, or requires these facilities. If it is to be his film, then he must do more than obtain the raw material. Yet though cinématography seems to be such a complex business, many experts believe that it is easier than taking stills.

Differences between Ciné and Still Photography

The major distinction between still and ciné is that ciné moves. Yet this apparently naive statement really gets to the heart of the problem. Taking ciné film of a static subject is not only a bore to watch but also misses the very nature of the medium. While the still photographer is searching out that moment where the subject becomes still or freezes, these are the very moments that the cinématographer seeks to avoid. Whereas movement can ruin a still, it is essential to an interesting movie.

The still photographer is concerned with obtaining the perfect photograph be it portrait, action shot or capturing an evocative moment such as a giraffe against a sunset. The movie maker, no matter how exciting and perfect his shots, must

ensure that he works from a variety of angles and distances, and that he uses a variety of lenses. While most still close-ups of animals, and particularly birds, are somewhat unpleasing, as they remove the subject from its background and frequently cut it in half as well, the use of super close-ups in movies is both dramatic and effective. The difference presumably derives from the fact that with ciné a variety of shots are joined together and the subject is established in its background and seen in close-up almost at the same moment. Stills, on the other hand, are usually seen in isolation, when the super close-up seems artificial.

If still photography involves spending more time waiting for the right moment to release the shutter, ciné certainly involves more initial thought and planning. Professionals, making feature films for showing in cinemas, work to the most elaborate plans imaginable. Each shot and camera angle is detailed in the shooting script and adjusted only after much thought during actual filming. Every shot, movement and word is rehearsed until it is perfect, and then 'taken' several times so that the director/producer is offered a choice for the final editing. Clearly such elaborations are seldom possible with wildlife movies. Animals do not learn their words, seldom turn up to rehearsals, and are just as likely to become temperamental stars and stamp off the set, as they are to give a repeat performance and allow a second 'take'. The wildlife cinématographer has to go through all the same preparations as the still photographer in his approach to his subject, but then has to do more. If he doesn't script as tightly as possible he will be unlikely to make a decent film at the end. Too much scripting is better than too little. The whole story must be planned to fit together which means taking continuity as well as main subject shots.

Because the still photographer is after the specific moment in time he tends to bring this idealism to cinématography with disastrous results. He will, for instance, be inclined to wait for the action to start before beginning shooting, completely ignoring the fact that when he presses the shutter release on a ciné camera he is not committing himself to a final result as he is with still photography. Thus on 'rushes', processed film

straight from the camera with no cutting or editing, it is quite frequent to see a hand covering or holding a subject at the beginning of a shot, or a lengthy shot of a thoroughly boring and empty scene awaiting the expected appearance of the star!

Format

The choice of format for wildlife movie work is restricted. Though the standard professional feature film format of 35mm has been used, for *King Elephant* by Simon Trevor for example, on grounds of cost and awkwardness of equipment alone it is ruled out for our purposes. Almost all professional wildlife cameramen use the 16mm format and it is this size that is used in the production of television nature films. There is also the 8mm format which is cheap and freely available. The standard 8mm uses 16mm film which is exposed, reversed, exposed again along the other side and then processed and split. There is no doubt, however, that the newer Super 8 will eventually oust the 8mm in this format size. It uses film specifically made for it, rather than split 16mm, and gives a larger picture size as a result. Most manufacturers are concentrating on Super 8 and their new cameras are not only cheap, but also highly sophisticated. In fact, many Super 8 cameras have features that are lacking in even the most expensive 16mm cameras.

There is no doubt that exposing thousands of feet of film is an essential part of anyone's training and a part that can be extremely costly. For this reason alone the beginner would be well advised to start with Super 8 with its cheap initial outlay and cheap film stock. The 16mm costs and weighs seven or eight times as much as 8mm.

Choice of Equipment

The characteristics of the equipment will be the same no matter what choice of format is made. A reflex view-finding system is almost an essential for much the same reasons as it is with still photography. It facilitates following a moving subject, and enables the picture to be accurately composed and focused

without parallax problems. As the reflex prism fits in front of the shutter the cameraman's eyes must fit light-tight against the rubber eye-piece or extraneous light will get in, and the film will be fogged.

Figure 11. Section through 16mm Paillard Bolex ciné camera showing viewing system and light path.

A through-the-lens metering device is to be highly advised too. With some cameras, mainly Super 8, this is automatically coupled to compensate for a change of light during the actual taking of a shot. Variations of lighting during a particular piece of action can ruin a shot completely, and even with such automatic controls an eye to the sky for approaching clouds is always a sensible precaution before beginning to film.

Power drive is a further essential of the modern movie camera. The old clock-work type is still freely available but has the habit of running out in the middle of a shot no matter

how systematic the photographer is at winding up at the end of each exposure. Clock-work drive has the further disadvantage of clicking loudly on and off in use, an attribute not renowned for putting wild animals at their ease as you film them. Electric power drive works off rechargeable or disposable batteries without the click problem. They should always be charged after use but as so much wildlife photography is pursued in out-of-the-way places it is always as well to take plenty of spares.

Batteries are built into some cameras and are additional to others. Built-in ones add weight to the camera in use, but otherwise there is nothing to favour one as against the other method, except perhaps that it is a good idea to have a clock-work mechanism to fall back on as a safeguard against flat batteries.

Lenses

Lenses for the wildlife cameraman must include a basic zoom. Just a few years ago people went wild with their zooms and some films consisted almost of a series of zoom shots strung together. Now the fickleness of fashion dictates almost no zooms. Doubtless some happy medium will prevail and the zoom lens will achieve its respectable place in the cinémato-grapher's armoury.

Zoom lenses can be used in three distinct ways: to close in on a subject during filming; to move out from a subject during filming; and as a simple device for changing the focal length of the lens without having to change the lens itself. Clearly the zoom lens has untold benefits for the wildlife cameraman. Having established the scene he can close in on his subject. He thus ensures that the animal or plant is set against its background in the most effective and direct manner. Zooming outwards has a similar effect but is best used where a particular point is to be made, like the effectiveness of camouflage. With this technique the audience already have sight and reference framework for the subject, but it still disappears before their eyes. Wherever the element of surprise is involved zooming out is more effective than zooming in.

The use of a zoom lens as a variable 'batch' of standard lenses in a single package enables the cameraman to find exactly the right focal length lens for his subject. If it is a bird sitting on its nest at close range he can obtain close ups with a 'different' lens without having to disturb the subject by actually changing a lens or manoeuvering a turret. Without a zoom lens the subject must be put off the nest before farther footage can be obtained with a lens of different focal length.

The standard zoom lens on the 16mm format is 25mm to 100mm. This can be detached or fixed on a turret along with two other lenses. With 8mm and Super 8 a zoom lens is now often offered as standard equipment, but is also frequently fixed and cannot, therefore, be interchanged with other lenses. Most wildlife cameramen working on 16mm will have several longer lenses to supplement their 25–100 zoom. A 200mm is very useful as well as a 300mm or even a 400mm. Such lenses are heavy, difficult to manipulate, and suffer from limited depth of fields, but they do bring real impact to close-ups as well as enabling unique shots at a distance to be obtained.

The photographer should remember that a moving subject is much more 'visible' than a still subject of the same image size on the film. Whereas, an active little bird should cover at least half the width of the 35mm still frame, it would be exceedingly unpleasant to view a movie that aimed at such a prominent subject. If the subject is active then sufficient room should be given for it to move about without the camera having to move with it every time the bird changes twigs. Flitting around like a machine gunner is bound to cause eye-strain to the viewer or be discarded in editing.

The still photographer should also remember that his 35mm lenses can be simply adapted to his 16mm movie equipment. They more or less double the effective focal length by being coupled to the smaller format. That is the 250mm on the 16mm format covers the same fraction of the film as a 500mm on the 35mm format.

Turrets currently available usually consist of three lenses, or lens positions, mounted on a circular plate that revolves to place each lens separately before the shutter. If long lenses are

used the simple parallel turret gives rise to 'cut off' problems. This means that a short focus lens can 'see' and will take film of the other longer lenses sticking out alongside. This is overcome by setting each lens at an angle to the others so that they flair away from one another.

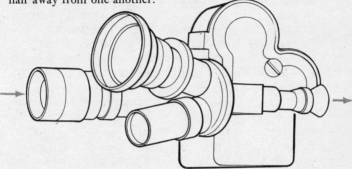

Figure 12. Flared lens mount on Arriflex camera.

Exposure

Exposing movie film is subject to the same principles that govern still photography save that instead of having variable shutter speeds, there are variable film speeds measured in frames per second.

The camera itself should offer a range of filming speeds. Much shooting will be at 24 frames per second (fps), if only because most television programmes are broadcast at 25 frames per second. Nevertheless, 16 fps. is standard and considerably more economical on film. Some projectors run at only 16 fps. and at this speed 24 fps. give a slightly slow motion effect. The aperture is varied in the same way with both still and movie. Thus in poor lighting conditions the cameraman may not only have to open up to full aperture but also to use a slower film speed—even 8 fps. When projected at 16 fps. this will speed up motion which may be acceptable with some animals and even add drama to others, but which looks decidedly of the Keystone Cops era when people are being shown.

When plenty of light is available, faster speeds can be used

to give varying degrees of slow motion effect. A speed of 32 fps. is very handy to eliminate the minute jerks and the tendency to move too fast from a pan shot.

A faster speed such as 64 fps. is true action-stopping slow motion and a significant weapon in the hands of the wildlife specialist. Many natural phenomena occur so briefly before our eyes that we cannot register how they are achieved. A small bird's wing movements are usually a blur. To slow down such movements so that they can be seen and analysed is not only good science, but makes absorbing viewing. Shots like ospreys, fish eagles and kingfishers diving into water for food produce superb drama if they are taken at fast enough speeds. Unfortunately really fast speeds, up to 200 fps., are not available on standard cameras and require a special camera such as an Éclair or a Mitchell. They do, of course, use the most fantastic amount of film in a very short time and can, therefore, be frighteningly expensive in inexperienced hands.

Drama can also be obtained at the other end of the scale by time lapse shooting. It is usually impossible to achieve very much with this technique outside a studio because of the effect of wind, either on the subject, such as a flower blowing about, or on the camera itself. Shots of flowers opening are now commonplace, as are plants shooting up from underground and clouds hurtling across the sky. It is seldom realised that almost every filmed sunset is obtained by a time lapse technique. With subjects like flowers, artificial light is crucial to obtain a uniform exposure over a lengthy period, and most of these types of shot are obtained automatically by an electronic exposure device, usually coupled to flash.

Blimps

Many animals are put off by the 'magic' eye of the camera pointing at them out of the photographic hide. Even more are upset by the sound of the camera. Whereas there is little that can be done about the former, except to get the subject accustomed to the 'eye', the noise problem can be overcome by the use of insulation—a blimp. Noise is only really a

problem when filming those animals that rely on hearing in their everyday lives. Birds have very poorly developed ears and make little use of this sense. Badgers have good hearing, a good sense of smell but poor eyesight. Thus it is possible to film badgers without a hide, but not without a blimp, in contrast to the filming of birds.

viewfinder

lens opening

soundproof material

a

Figure 13. (a) Eric Ashby's blimp for filming mammals (From *Making Wildlife Movies* by Christopher Parsons)

shutter release

Figure 13. (b) In addition to acting as a blimp, the Hasselblad protective cover both camouflages and keeps camera and lens dry

A blimp consists of a box or jacket filled with sound absorbent material like expanded polystyrene that fits round the camera while still enabling the controls to be used—like an underwater housing. Nevertheless they are awkward things to work with and an encumbrance to the fast travelling, compact wildlife specialist. They are, however, essential, particularly when recording simultaneously, when the noise of the shutter can appear on the sound effects.

Camera Support

If a tripod is to be highly recommended to the still photographer, the movie maker would be well advised to buy his tripod before his camera. A tripod should be as sturdy and heavy as possible commensurate with the requirements of travel and convenience. A lightweight tripod is better than nothing—but only just. See Chapter 1 for full tripod details. A jogging frame causes considerable eye-strain to watch, but whereas a misaligned horizon can be corrected on black and

white stills and moved around even on colour transparencies, a sloping sea on movie film is an uncorrectable disaster.

There are some occasions when a tripod is inconvenient, as in following flying birds, running animals, and in the confines of a car. But even in these circumstances there are extra supports that can be used to eliminate shake. A tripod is both easy to carry and to use and has the advantage of eliminating most of the up and down movements. A similar result can be obtained by placing a string under the foot and pulling against it while panning. Sideways movement is certainly more acceptable than vertical jerking.

Shoulder pods, the more elaborate and more firmly fixed to the body the better, have distinct advantages. They are used in television for small cameras taking the intimate close-ups that tell the 'real' story at sports meetings, and by news cameramen for impromptu shots. The improvisations that can be achieved are many though several well-tried techniques for keeping cameras still are detailed in Chapter 1. A cable release is very valuable for use in conjunction with a shoulder pod as well as for panning and in hides.

Camera Choice

When it comes to the camera itself there is comparatively little choice open to the 16mm specialist, whereas the 8mm and Super 8 user would be hard put to find out about all of the alternatives, so fast are such instruments being produced. To offer advice in these formats where design is changing so rapidly would be sheer folly. Instead we recommend the purchase of a camera and lenses to be based on the criteria set out earlier in this section and summarized here:

1 Reflex Viewing System
2 Interchangeable Lenses
3 Power Drive
4 Variable Speeds 8–64 fps.
5 Footage Indicator

Within this framework the more that is spent the more is obtained, but as always money spent on a good lens is money well used.

The same criteria apply to 16mm cameras but only three manufacturers really measure up to the requirements of the serious specialist to whom this format, by virtue of cost, must be confined.

The Swiss Bolex is the best known and has been a leader in the field for many years. Its position, however, is being threatened by the French Beaulieu and the German Arriflex. The current model Bolex has all of the features required, plus the facility to attach a 400 foot magazine, and a clock-work wind should the power drive run out. Neither of the other makes have this latter fail-safe device. Nevertheless, most of the professionals have gone over to Arriflex and there must be good reasons for their doing so.

The film stock and speed used in cinématography are familiar to any still photographer. Kodachrome, Ektachrome and so on are all available. But as their colour balances differ, care should be taken when mixing them in the final film. Speed of film will be chosen not so much for stopping action (that's unnecessary with movies) but for the conditions under which it is anticipated working. Choice will depend also on the use to be made of the finished film. If it is to be shown by yourself to a few friends or the local natural history society then only one copy need be made. If it is commercial involving several or even hundreds of prints then a different film stock will be best. For most purposes where only one or two finished copies are required reversal stock will be preferred.

Scripting

To make a movie is to tell a story. Not surprisingly companies engaged in making wildlife films employ specialist story-tellers so that the cameraman can concentrate on the actual business of obtaining the footage. The story-line is the starting point of a film. It might be a simple one like *How We Went to Iceland to Find the White-tailed Eagle* or the *Breeding of the*

Blackbird, but it could be as complex as the *British Hedgerow* or *The Survival of Wildlife in South America*. Having worked out the idea a shooting treatment is the next stage. An example will help:

Subject:	The Bongo Swamp
Script:	John Gooders
Cameraman:	Eric Hosking
Date:	31-8-73

Shooting Treatment

Action

Pan from close-up of dawn reflection on water to large mammal statuesquely waiting to drink—all bathed in oranges and reds.

Super close-up of tsetse fly on native's arm sucking blood, ditto on lechwe's back. Lechwe jump in S/M about the marshes disturbing egrets, etc.

Close-up of flowers ripped out by crash, close-up of dredger at work.

Zoom out slowly to establish dredger.

Commentary

When Dr. Mackay discovered Bongo Swamp in the late 1880's he described it as a desolate wasteland and harbour of disease. Malaria and the tsetse fly thrived while bilharzia was the scourge of the district.

But there is a wealth of life that the good doctor ignored. Fish there are in profusion and large game herds that make the parks of East Africa look like children's zoos. Lechwe bounce their way across the reed-fringed pools while a wealth of wild birds hide away in the jungle of reeds.

Today bilharzia and malaria no longer threaten Bongo Swamp. Today it is the diamond mines to the north that want to suck the life blood out of the wilderness.

Scripts of wildlife films are inevitably more vague than those of the feature film or even tightly budgeted human documentary. But the script must direct the cameraman to the subject in all of its aspects. He must know what is required of him for continuity—usually over half of a completed wildlife movie does not show wildlife—and he must know which of the opportunities for extra shooting, that will inevitably come his way, are worth taking and which are best ignored. If he is shooting a film on a Greek lagoon and a white-tailed eagle suddenly lands within filming distance he would be foolish not to take advantage of the opportunity presented. If, however, he is working on a film on the white-tailed eagle and a rare wader happens to fly in, then whatever the quality of what he shoots it will almost certainly be discarded at editing. Sequences, no matter how good, must fit into the story or be thrown out.

Of course, some sequences may be so brilliant that it is worth re-writing the script to include them, and there are invariably sequences that were unexpected but which can be accommodated within the planned structure with just a little bending. This is the very crux of filming wildlife. A story-line must be established and scripted as closely as possible, but the footage that is finally obtained must be structured so as to look as if every shot was intended.

The easiest script to write consists of a commentary illustrated by film. This establishes the story-line strongly but has the disadvantage of not thinking in terms of film but in words. A better script is a mixture of film ideas and word ideas put down at one and the same time with neither aspect taking precedence over the other.

Most amateurs will not use a commentary on their film for reasons mainly of cost, but this does not mean that their films are excused from telling a story. The plot must be as strong as in any 'talkie', perhaps stronger, for it must be obvious without utilising sound. Thus somewhat different editing and, to a certain extent, shooting techniques are required.

A good script tells a story and includes a number of milestones. These are the essential parts of the story without

which it ceases to exist. It would, for example, be a pretty poor film about robins that did not include their territorial displays, and did not show the importance of juvenile plumage in maintaining the parent-chick bond during the post-fledging period.

Shooting Plan

Having established the story line, worked out the script and picked out the milestones, the photographer must decide in what order he should shoot the material required. There is no reason to work on a strict time scale, progressing season by season through the year, if the calendar is unimportant to the story. Put simply, the sequence of taking shots does not determine the sequence in which they will be shown.

Every good script will detail continuity material, but so too will every good cameraman ensure that he has what will be required for the film, whether he is told at the planning stage or not.

Scenics, for instance, help to put the subject in perspective and establish it as part of something larger. The human interest may be maintained by slipping the odd person into the film rather than pretending that people don't exist at all. Such material should be shot from a variety of angles and with a variety of lenses so that complete sequences can be achieved in editing. Many contemporary wildlife films tell the story of how the film itself was obtained. It is a useful way of maintaining interest in wildlife, but perhaps there are too many such films around, certainly they under-rate the attractions of wildlife which seems rather a strange view for the film-makers themselves to hold.

Shooting

Shooting is as complex an operation as the photographer cares to make it. Good wildlife filming depends on the imagination of the cameraman in interpreting the script and understanding the techniques of editing. Without the basic understanding of what the script aims at and what the editor would ideally like

to have available, the cameraman will do a less than ideal job and the finished result will be a less than ideal film. The cameraman is a sort of visual poet.

Each shot required must be perfectly filmed and then shot again from another angle or from a different aspect. It is unsatisfactory, for instance, to show a bird returning to its nest to feed its young flying in from the left, feeding the noisy chicks and flying off again, without showing how the bird obtained the food and particularly its stealthy approach to the nest. During editing, such shots will be overlapped from the time aspect so that the same action is seen from two distinct viewpoints in consecutive shots.

Pans and tilts, zooms, slow motion, time lapse, tracking, fade-ins and fade-outs, close ups and long shots, all are available to the wildlife cameraman. But all should be used only to add to the story and with a definite end in view, not indiscriminately for effect. Each technique has its own skills. A pan must be smooth not jerky; it should be slow enough to see what is passing without blurring by like the view from a train window. If it is wished to pan or tilt from one subject to another it is crucial that the camera arrives at exactly the right spot with the fresh subject bang in the middle of the frame. If it isn't, do it again. But whatever happens do not jerk around 'looking' for the subject. Many wildlife cameramen have this jerk and search problem when they start. Hundreds of feet of film are wasted as they hunt around waiting for something to happen. At a seabird colony, for example, it is so easy to switch the camera on and pan, tilt and zoom around the hundreds of birds, searching for courtship display or a territorial dispute. Usually such searches are fruitless and wasteful. Watch first, film later, should be the golden rule. A few typical filming situations will help our understanding of the techniques and skills involved, remembering that each roll of film should ideally start with a slating shot on the film box.

Shooting from a vehicle on safari, the major problems are to achieve steadiness without a tripod, and the desired filming angle without disturbing the subject. Steadiness for a still camera can be achieved by utilising a support on the window

or roof of the car, but moving the ciné camera to pan, for example, poses problems. This is a case for the use of a shoulder pod finding as much support for elbows and body as possible. Rehearse the movement as many times as necessary until you can feel that the pan is smooth and steady before taking. Even a static subject like a cheetah dozing in the sun will eventually get up and do something and, as it is exactly at this point that movies start to 'live', you will want to follow the action.

Panning is different in a number of ways from following action. Whereas the pan is rehearsed the action following shot is invariably spontaneous. Because it is planned, each pan should start with a static shot for a few seconds before moving away, and end with a further static shot. Both of these static shots should be as well composed as stills and as carefully thought out.

Obtaining the right angle may be a simple matter of driving the vehicle round to get the background you want; an attractive foreground framework like a tree on one side of the frame; or the light behind you. Often it will be a combination of these, and more often still there will not be a 'right' angle for action is best shot from a variety of angles. Thus a galloping herd of wildebeest could be shot from a half-front angle, coming towards the cameraman but across the screen, or directly from the side. The latter becomes very boring after a few seconds unless some additional action can be added to maintain interest. One of the best shots we have seen of migrating wildebeest used a side-on shot of thousands of animals passing as a background to a sub-story of a male rounding up his harem. Animals thundering over and past the ground level head-on camera are still highly effective, in spite of having been used in almost every 'western' ever made. These shots can be put together by the editor to build up a sequence, but wildebeest also give birth, are preyed upon, cross rivers, fight and die on their migrations, and further sequences can be built on every aspect of their lives.

Tracking poses problems all of its own but is often very useful in following the action or in recording a journey. In both cases steadiness is the major problem. While filming, say,

gazelles the cameraman will have to follow in a vehicle or on foot. The jerkiness of both methods creates fundamental problems. Filming from moving vehicles is simple enough provided that the camera is secured firmly to the framework and that a part of the car itself shows in the viewfinder to form a steady frame of reference to the jogging subject outside. Following a subject with a hand-held camera while walking can also be achieved provided firm supports and strapping are used. The usefulness of such shots will depend ultimately on the other shots that can be cut in with them to form an acceptable sequence. These will consist of views from other angles of the subject as it passes, be it animal, person or vehicle.

Situations requiring hides usually involve dealing with timid creatures where disturbance must be kept to a minimum. It is thus not feasible to follow a subject for more than a few degrees either side of centre without it noticing the movement of the camera lens. It is also difficult to change the lens and to take accurate light readings without a through-the-lens metering system. Perhaps even more so than with still photography an assistant can be very useful, not only in installing the cameraman (see Chapter 3), but also in being on hand at signalling distance to move the subject away from the hide temporarily, while lenses are changed or light readings taken. He may also help to persuade the subject to 'perform' properly.

At a hide on a marsh frequented by feeding waders, for example, it is often possible for an assistant to move a subject away from the hide and then to move it back again by careful driving, or simply to move subjects nearer to the hide and even flush them on the signal from the cameraman. With nesting birds action can be created in the same way but great care must be taken to ensure that the safety of the subject always comes before the convenience of the photographer.

Fade-ins and fade-outs have largely passed out of fashion in recent years, probably as a result of the greater sophistication of audiences following the revolution caused by having to watch television advertisements where every second costs a fortune. This increased understanding enables editors to cut from one subject and one time to a completely different subject at a

different time without confusion. As a result techniques like fades and mixes that signal the passing of time are largely redundant. In the processing studio they are expensive and in the camera they are frequently inconvenient for editing.

Even with the best scripting many wildlife cameramen tend to leave the continuity and establishing material, on which the story-line ultimately depends, until last. Usually no more than fifty per cent of a finished movie consists of hard-core wildlife. The rest is scenery, people, travel, mood sequences and so on. Naturally, perhaps, the wildlife cameraman thinks of the wildlife action 'nuggets' as being the backbone of the film, and leaves the rest to be shot in a rush at the end. Certainly there is no point in shooting all of the continuity material and then failing to obtain the real wildlife shots that were planned. But the mad-rush approach is equally short-sighted. Some continuity, as in the case of a journey, must be shot as it happens, otherwise the journey will have to be repeated, 'faked' at a later date, or even left out altogether. To exhibit jewels in a poor setting does them less than justice—it is the same with really good wildlife film sequences.

Editing

Given that the cameraman obtains all of the shots required by the script, and builds them into sensible sequences by filming from different angles using the skills of his trade, then the editor has the job of building the finished film. To do a good job he must understand exactly what the point of a sequence is and how it fits into the overall plot. He must view all of the material and decide what can be used and what cannot. He must decide which shots of a given sequence are best and which must be discarded. He may then group similar shots together in a rough-cut that will be perhaps half as long again as the finished film. The story should flow through this rough-cut which is a sort of visual first draft.

Then comes the real skill of editing which centres around how he cuts from one shot to another. There are general rules

that it is best for him to follow. He should avoid jump-cuts where the subject is shown across a cut in two very similar positions. On projection this will make the subject appear to 'jump' from one part of the screen to another as if there was a piece of film missing. He must try to cut during action rather than from one static shot to another, and move from film shot on one lens to film shot on another. Ultimately, however, it is the imagination of the editor that counts. A good editor can put run-of-the-mill film together in a truly exciting way. He can build a story where very little exists, but with really first rate shooting offering real 'nuggets' of action and variety of shots he can produce a masterpiece.

Most amateur editors rightly try to keep their treatment simple, but most make the elementary mistake of using shots of too long duration. Watching even the world's rarest animal from the same angle doing nothing is boring after a few seconds. Action and excitement can be created by cutting from one shot of a couple of seconds to another equally short. But mood creating at such a pace would be self-destructive. Feelings of peace and beauty are created by a more leisurely treatment using pans and lengthy shots of seven or eight seconds.

Many movie makers prefer to employ a professional to edit their film. This should produce a better result and has the quite distinct advantage of impartiality. While it is difficult to judge one's own results, it is virtually impossible to leave out a sequence when the labours involved in obtaining it are still vivid memories.

At the end of the production it is very likely that the editor will have to leave out a large proportion of even the correctly exposed and well composed material. A fair ratio is 3 : 1 or 4 : 1 but most television films work on 8 : 1 and 10 : 1 or even worse. Remember 1,000 feet of 16mm film runs roughly half an hour at 24 fps. Then work out the cost of 10,000 feet of stock plus processing, the cost of printing much of it for editing, then editing, then printing the final copies, then decide whether it really is such a good idea to take up wildlife movies after all.

Lighting

Some animals, either because of their habits, size or a mixture of both, require an extra light source in order to be filmed at all. Nocturnal animals like owls and badgers come to mind, along with birds that nest in the dark inside holes, insects that are so small as to require a close-up approach, right down to microscopic animals that can only be seen via powerful magnification. Still photographers have few problems in this area. Their flash sets and the light produced may frighten the larger subjects, but by then they have obtained their results, and only have the inconvenience of waiting for the subjects to settle down or reappear before they can continue work. Certainly the flash does no harm to the subject. Cinématography is completely different.

Nocturnal animals may accept a flash, whereas the continuous flood lighting required to make movies will be either completely unacceptable or take a great deal of time and patience to accustom the subject to it. With cinémacrophotography the problem is that the light required to illuminate the subject in the studio also produces sufficient heat over a short period literally to fry the subject. These two problems have been overcome by Ernest Neal in his badger work and the Oxford Scientific Film unit in their work on insects and other small subjects.

Gerald Thompson and his colleagues at Oxford have developed the art of macrociné to a high level. They have designed and constructed special lamps with filters that absorb a high percentage of the heat while allowing over ninety per cent of the light to pass through.

A further problem of macrociné with lamps is that of shake. The camera itself has moving parts that, albeit minimally, keep the lens in constant motion. With normal photography such shake is negligible but with high magnifications up to 1 : 1 shake really does become a problem, while with greater magnifications it becomes as paramount as lighting. A concrete floor and heavy tripod are essential even for low magnifications, but at macro level even these devices are insufficient. OSF

initially solved the problem by using stands weighing 300 pounds or more, but they now have a more manageable system of rigidly mounting the camera and the subject together so that they shake in unison. If such a device sounds simple try constructing a mount that, while maintaining rigidity, also allows movement during actual filming in all three planes.

Ernest Neal's problems were different. He had to accustom shy creatures like badgers to long periods of floodlighting. These animals normally emerge only after dark, so Neal had to utilise a dimmer so that the lights could gradually be brightened to the level required for shooting. Over a period of weeks he had to get the badgers used to lights at increasing intensities while continuing their natural behaviour.

The problems with artificial floodlighting are not solely concerned with the shyness of the subject. Floodlighting requires an adjacent mains power supply, and freedom from human and animal disturbance. Equipment must be left in place with the sure knowledge that neither the inquisitive nor the vandal will disturb it. If advanced photomacrography requires a knowledge of physics and photography, then floodlit photography requires a particularly good knowledge of natural history.

The Inanimate World

Nature does not consist only of animals. Flowers and plants, trees and lichens, volcanoes and glaciers, minerals and land-forms all fall within the scope of the natural history photo-grapher. Nor must it be thought, because these subjects do not run away, require large telephoto lenses or even any specialist equipment, that they are simple to photograph. Some of the finest natural history photographs are published in *Audubon*, the magazine of the American National Audubon Society. In its pages you can see how beautiful a still life of mosses, bark and flowers can be. Try to achieve the same high quality results and you will see just how difficult such shots are to obtain.

Choice of Equipment

The sheer wealth of subject matter within the inanimate world and the variety of techniques that are available make generalisa-tions difficult. But, as always, the use to which the results are to be put will help settle the problem of format and camera type. Only with landscape and still-life photography does the opportunity to use a larger format than the $2\frac{1}{4}''$ square really arise. Where time is on the side of the photographer rather than on that of the subject, larger cameras and tripods can be used with benefit. Thus the photography of trees, or of the effects of glaciation on the landscape, present different problems from that of snapping a running antelope.

Ease of handling becomes subservient to the quality of the finished transparency.

A great many photographers, however, work on the $2\frac{1}{4}''$ square format simply because of its versatile convenience and the excellence of the equipment available.

Flowers and Ferns

As with all natural history photography the choice of subject is important. A fine mature lion makes for a much better photograph than a seedy, lethargic old one. A bird in spring is usually better looking than one with abraided feathers at the end of the breeding season.

Unfortunately the photographer on safari does not always have the choice that he would like but, in contrast, the flower specialist usually has a large number of individual examples from which to choose. It is important that this choice is used wisely. In a field of orchids some will be dying, others budding and some just right. Similarly with ferns, except perhaps here there is no obvious flowering climax, and the subject presents attractive photographic opportunities from budding to the muted colours of autumn. Lighting and shelter must also be considered in choosing a subject. Though clearly interrelated there is no paramount need for either to be absolutely perfect if, let's say, a rare flower has been found.

The use of artificial lighting frees the photographer from dependence on the sun and also helps, by speeding up the exposure, to reduce the need for shelter.

Nevertheless, most flower photographers are looking for a bright windless day on which delicate leaves and petals will remain still, for even a gentle breeze can throw a small flower all over the place. To minimise disturbance, wind-breaks like those used on many northern European beaches are an essential part of the equipment. These are made of perspex rather than striped canvas, though in an emergency polythene will serve. The point is that though keeping off the wind the screens should not reduce the light falling on the subject, and they should be transparent so that the background remains natural, albeit out of focus. The same technique applies to photographing any animal that lives on the plant or flower, for as the wind moves the bloom so it will move the caterpillar that feeds on it.

In general, however, the best shots of insects will be obtained under controlled conditions and whereas these small creatures

can be transported without loss of life, a plant generally suffers by being moved.

Close-ups

Most flowers are small and the photographer must employ one of the methods of approaching his subject more closely than allowed by the normal standard lens. Some flowers are very small indeed but most are three or more inches in height and do not, therefore, take us completely into the realm of photo-macrography. Smaller flowers are like large lichens and should be approached in the same way. Because of their modest size, equipment may consist of either the standard 50mm lens on the 35mm format together with one of the close-up devices detailed on pages 37–39, or use may be made of the specially calibrated 'macro' lens that focus from infinity down to a few inches. In our view these lenses are ideally suited to the less than macro area of flower and fern photography.

Having taken pains to eliminate movement of the subject as far as possible, the photographer must mount his camera on a firm tripod to prevent movement. With bankside flowers and ferns a normal tripod with variable leg height will prove ideal, but with small flowers growing on level ground a special minimum elevation tripod must be used. These are often referred to as 'table-top' tripods and are available from several manufacturers.

In such situations, the most likely to be encountered by the flower specialist, the use of a pentaprism viewfinder can prove almost impossible. To get the eye to ground level is bound to be awkward and certainly not conducive to careful composition. We find waist-level viewfinders particularly useful here, though they are not interchangeable with the pentaprism on all 35mm SLR cameras. Some cameras have a 45 degree penta-prism that is invaluable in these circumstances.

Instant Photography

As in the field of bird photography, a new army of action-

snappers has grown up in recent years. They work on the assumption, perhaps unformulated, that the 35mm camera and film are adequate for all their needs and that the most important thing is to build up a portfolio or library of colour slides of as many flowers as possible.

Of course, in many ways they are right for there are many subjects, especially outside the 'flower' areas of Britain and the United States, that have never been photographed in colour. This sort of collecting is perhaps as valuable in its way as the earlier botanists touring with their flower presses. Plants can be examined and compared at leisure in their natural colours and environment, rather than in that strangely lifeless, pressed and faded form.

The instant flower photographers work on the simple assumption that if natural daylight is swamped by electronic flash the exposure is brief enough to stop all movement of the camera and of the subject in the wind, and also powerful enough to produce an adequate depth of focus. Basically they are correct but the resulting photographs do suffer from the harsh shadows created, the lack of 'naturalness' in the subject itself, and from the pitch black backgrounds that produce a 'night-time' effect.

The most usually adopted equipment consists of a 35mm SLR camera with a 'micro' lens or a standard lens with extension tubes or bellows. A small electronic flash unit is mounted on the top of the camera by a boss that enables it to be tilted up and down, according to the distance of the camera from the subject. Hand-held the camera is focused, the shutter released and the exposure made in just a few seconds.

Needless to say the results are not to be compared with those of still-life artists, to whom no trouble is too much to obtain the perfect portrait, but then that is not the aim.

By and large flowers look more dramatic if they are shot at their own level rather than looking down on them. Depending on the subject, some are best photographed in groups or clumps whereas others are more attractive on their own. A bluebell looks quite strange by itself without a background of other, albeit out of focus, blooms whereas an orchid can only be

seen in all its glory against a muted neutral background. Where clusters of blooms are found—and fields of orchids can still be found here and there—the opportunity to take individual blooms, as well as medium and even wide-angle shots, should not be missed. Even on a single plant like a lily the individual bloom makes a picture on its own.

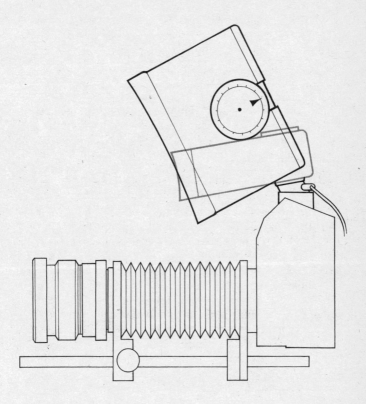

Figure 14. Small electronic flash mounted vertically and horizontally on SLR. Its angle can be adjusted according to distance of subject. The bellows extension is for close-ups.

Overcoming the major problems of shake and movement with tripod and wind screening allows the photographer to work at slow speeds and thus obtain the depth of focus required to photograph flowers. Nothing is more unsatisfactory than a photograph of a flower partially out of focus. The stem, leaves and bloom should all be crystal sharp and stand out from the blurred, out-of-focus background. If it is possible to work at 1/25th sec. then there is advantage in doing so. Discreet use of flash as a fill-in to natural lighting will enhance many pictures and in many circumstances give just that little extra light to enable adequate stopping down.

Trees

Trees are just like flowers on a larger scale. The same care should be taken in choosing the subject, but whereas the flower specialist may have hundreds of plants to choose from, the tree photographer may have to travel for miles to find the subject he wants. Many trees grow in woods or forests, and here the problem is to find the right angle to isolate the subject from its surroundings. Unfortunately most trees that stand on their own grow in hedgerows and have inevitably been pollarded or lopped so that their natural shape has been lost.

Undoubtedly the best examples of trees standing on their own to display their full glory are found in the private parks of large mansions—just the sort of places that are being opened to visitors either by their owners or by the National Trust. Kew Gardens in London is, of course, a marvellous place to see and photograph a wide variety of individual species of tree. What is more, they are all accurately labelled so that there can be no doubt about their identification.

A windless day is even more essential for trees than for flowers—transparent screens of the size required are clearly out of the question. A standard tripod is essential, as is a cable release. Though, perhaps the major difficulty of tree portraiture centres around the problem of perspective. Being so tall, trees pose the same problems as large buildings, the photographer is at the base with his subject towering in the sky above

him. The foreshortening, so obvious in a badly taken architectural photograph, is less obvious in the case of trees because of their lack of a definite line.

While we know that a tower block does not taper into the sky, most trees do taper and the camera's accentuation of the fact is less noticeable and, therefore, more acceptable. It is possible to reduce this effect by raising the camera height and even a few feet rise to the roof of a car can make a significant difference. Inevitably the camera must be tilted upwards to compose the subject but the less tilt the better. For this reason the standard lens is better suited to tree portraiture than the wide angle lens because of the need to work farther away and, therefore, at a less acute angle.

By the very nature of the subject, tree photography is well suited to the plate or roll film camera. Trees do not run away and can thus be worked with heavier and more cumbersome equipment.

Many plate cameras have a rising front, that is the lens can be raised or lowered from the horizontal plane. Even a small raising of the lens is equivalent to raising the camera several feet. This has the effect of eliminating the tendency of trees looking as if they were about to fall over backwards. The use of telephoto lenses is another valuable device on the smaller format cameras. The 135mm lens enables the photographer to stand well back from the subject and even take shots of trees on private land without trespassing.

Though the portrait of the summer tree in all its glory will be the primary photograph, full documentation requires more detailed shots. Close-ups of the leaves, flowers, buds and fruit are not only very useful but also offer significant photographic challenges in their own right.

We have seen some marvellous close-ups of even a single leaf—with dew in early morning light they can be quite breathtaking. Larger close-ups, showing leaf structure, depend on carefully controlled lighting and are, perhaps, best taken under studio conditions. Bark patterns are fascinating and trees in winter, stark structures against the sky, are a complete subject on their own. The complete tree photographer requires shots

of every aspect of the life of his subject, and will be satisfied with nothing less.

Lichens

If trees are the largest subjects that confront the natural history photographer then lichens are among the smallest. Though they grow to enormous lengths from the coniferous trees of northern forests, many are very small—less than an inch in height—and require all the elements and skills of photomacrography to capture properly. With a subject that can only be seen in detail with the aid of magnification, a close approach is absolutely essential.

Thus, by the nature of the subject itself, photography of lichens requires the use of extension tubes or a bellows. As with other small subjects the use of artificial light is advisable so that a wide depth of field can be obtained. The basic flower photography outfit is ideal with a small electronic flash close to the taking lens. This will enable small stops of f16 or even f22 to be used.

Many specialists prefer the natural results obtained by sunlight in spite of the additional problems posed. Lichens invariably grow in large groups, a fact that the harsh illumination of flash tends to obscure by picking out a narrow well-lit subject and casting the surroundings into deep shadow or total darkness. Nevertheless, a sufficient depth of focus must be obtained and, with natural lighting, this involves using a slower shutter speed. With an immobile subject there is no reason why speeds of $\frac{1}{2}$ sec. or even longer should not be used, provided that all movement of the camera is eliminated. The normal tripod is, however, totally inappropriate and resort must be made to the tiny 'table-top' supports. These raise the camera no more than six inches, while providing the firm support necessary for lengthy exposures. Unfortunately, the action of the mirror in many SLR cameras is often sufficient to joggle the camera during exposure, and many photographers make a point of locking it up while making time exposures.

A cable release is required, but use can also be made of the delayed action that is built into most cameras. This is the device that delays exposure until the photographer himself has joined the subject—or at least that is its most common usage. It can, however, be substituted for the cable release by setting and releasing the mechanism and then letting the camera and tripod alone to make the exposure untouched by human hand.

Photographs of lichens can be among the most beautiful of wildlife subjects but they do require care, thought and preparation. Those who wish to snap quickly and move on would be well advised to forget lichens.

We recently saw a professional, working for one of the mass circulation American magazines, take half an hour photographing a single lichen subject by natural lighting, and although that seemed excessive we are sure that he erred on the right side. Treat the subject as seriously as you would any other and there is a chance of obtaining the best results. One last word of warning, very few people are able to identify lichens accurately and even the specialist usually requires a specimen rather than a photograph. So if you value the accuracy of your labelling take advice before you shoot.

Fungi

Fungi too, are difficult to identify in spite of their often bright colourings and apparently distinctive patterns.

Most are prominently three dimensional and, therefore, pose problems of depth of focus. In this case the problem is so serious that the use of artificial light is almost a necessity. An average ground growing fungus is three inches high and three inches across. Thus a portrait will have to be taken at a range of about twelve inches, at which distance three inches minimum depth of focus will necessitate the use of f16 or f22. As most fungi grow in woodland the natural light is seldom sufficient for the purpose.

The 'flower outfit' is ideal, but rather than use tubes or bellows we prefer to make use of the special micro lenses that

enable us to get to within range of the subject without any auxiliary aids. A tripod is as essential as ever.

Choosing the best subject is frequently a matter of knowing exactly the right time of the year to look. Fungi are extremely ephemeral, appearing overnight and deteriorating very rapidly thereafter. So a basic knowledge of the fungi of your own area is an essential preparation. In Europe and North America autumn is the great time for 'fungi forays'.

Choose the subject carefully. Ensure that the background is typical. Some fungi, for instance, only grow on old pine cones and are best photographed against a bed of brown pine needles. Others grow only in deciduous woodland though they can, of course, be found in mixed forests. A certain amount of 'gardening' is often required to remove out-of-focus grasses, dead leaves and other woodland debris.

The same attention to detail should affect the way the background is selected and arranged—the usual factors of avoiding highlights, etc.

Invariably the photographer will want a variety of shots. Though most will include a portrait taken slightly above and at an oblique angle, he may additionally require a direct view from above (as with the so-called 'fairy rings'); a view from below to show the gills or tubes underneath; and perhaps a view of the 'root' together with the typical host of the species concerned.

Non-living Subjects

In the field of non-living subjects there are several that have traditionally interested the wildlife photographer. The wild landscapes, mountains, jungle, marshes and isolated islands and stacks that he frequents more than most other groups of people are bound to stir him to photography. But landscape photography is not a subject that we can deal with here—it is worthy of a book on its own.

Of course, in its widest sense everything is 'natural' but subjects like geysers, volcanoes, glaciers and minerals somehow seem more 'natural' than others. Photography in all of

these cases is more a matter of getting equipment to the right place, at the right time, under the right conditions, rather than any specific skill in the taking. The general rules of composition must be adhered to but without clouding the central object of portraying the subject. Care, time and patience are the key words as in all wildlife photography.

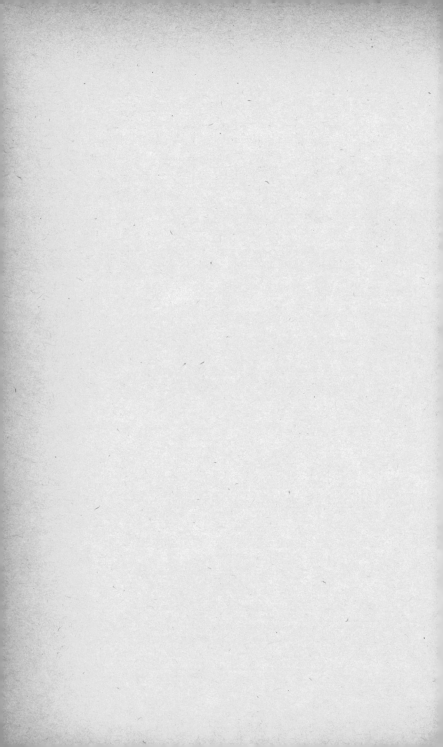

8 The Ethics of Wildlife Photography

Ethics are rules that we impose upon ourselves. Such rules are to be distinguished from enforceable laws like those of society, clubs or our employers. They are, by definition, unenforceable. Often, however, such rules are embodied in a legal code. Thus while it may be a moral rule not to steal it is also a legal requirement in most societies. On the other hand it is a purely moral question whether or not you should be honest, keep your word, etc. We may learn how to behave by parental pressure, or educational example and even punishments, but ultimately our code of ethics is our own affair.

The morals or ethics of wildlife photography are rules that the photographer accepts for himself. They are not rules like obtaining a licence from the Nature Conservancy Council to photograph the rare birds on Schedule One. The latter is a law of the land, not a moral rule. He who breaks it may be punished but he may, or may not, feel guilty.

By and large the wildlife photographers' code of conduct has been formulated in a free-lance fashion predominantly through a series of books on bird photography. Though mainly concerned with techniques and equipment, each book also seeks to establish a remarkably similar code of behaviour. This can be summarised as follows:

1. the animal's welfare must come first at all times
2. the animal to be photographed is wild and free
3. true skill lies in pitting one's wits against such a subject successfully
4. satisfaction is obtained in the hunt and achievement.

While there can be little doubt that most wildlife photographers have always accepted such a code, film makers have

always adopted a slightly different position. Their problem has not been to capture a fleeting moment, but to record in movement the very nature of their subject. At the end, their enterprise must tell an interesting story.

Inevitably the cinématographer must edit what he has achieved, often changing the time sequence and re-arranging so that what emerges is more than a simple record. Only the most *avant-garde* are prepared to make a film of several hours non-stop looking at a New York office block—and only the most masochistic are prepared to sit through its showing.

In the process of editing, the film maker distorts nature in a way that the still photographer does not. Perhaps it is not then surprising that he is prepared to go much further in obtaining and putting together what could easily be called 'fakes'.

Our major point is, however, to examine the fundamental attitudes of still photographers in relationship to this generally accepted but hitherto un-written code. From the Keartons onwards the classic bird photograph was taken at the nest soon after the young hatched, save only when photographing species like the lapwing and other ground nesters that produce nidifugous young which need to be photographed on eggs. The photographer would work from a hide that had been carefully moved up in stages over a period of several days to within a few feet of the nest. The general dicta were at all times: be prepared to abandon photography if the subject would not accept the hide, always use a companion to enter or leave the hide, and always choose a nest that was unlikely to be disturbed by the curious.

This system of working evolved quite quickly in the early days of bird photography, as a result of experience. The whole aim was to protect the bird and its nest, while obtaining portraits of them going naturally about their business. The resulting photographs would thus be 'true to nature'. This practice could be, and was, criticised as being extremely dangerous simply because it used the powerful draw of the nest and young on birds to overcome their equally natural drive to avoid the danger of, what to them was a tower-block of a hide tent. It could easily be argued that the strain imposed on

the bird was unacceptable. Just at the time when the parent birds have to rapidly change from incubation of eggs to the feeding of young, the photographer subjects them to drastic disturbance.

It could, however, be argued that the use of photographs was so influential in publicising the cause of bird protection that the cost of a single nest was immaterial. This we find totally unacceptable, and would expect most people with an interest in wildlife and conservation to feel the same.

Alternatively, and more plausibly, it could be argued that the birds were never strained at any time during this process, or that if they were they soon recovered and accepted hide, lens and flashing lights. The photographer could say that the non-photographically minded have never experienced the reactions of birds in this situation and could not, therefore, judge whether the bird was strained or not. There is little answer to this. It might, however, be more convincing if the photographer was prepared to be judged by his results and here we do seem to have an acceptable, and independently assessible, criterion of judgment.

If the bird is frightened and ill at ease the photographer can be condemned. If it looks as if it is behaving perfectly naturally and oblivious of what is happening to it then all is well . . . or is it? A bird with its bill half way down the gullet of its chick is at ease? Another with a frightened look in its eye is not? Must one see the eye to judge? And more important still who is to judge? Most of us seldom get near enough to a bird to look into its eye let alone see whether it is afraid. Bird photographers do so frequently, but then no man should be judge in his own cause, so we cannot accept their view. Besides which it would, of necessity, mean admitting that they have seen fear in a bird's eye to be able to recognize it again. In the view of ethologists ascribing fear is to be simply anthropomorphic.

Moving away from the nest and hide situation introduces new elements into the debate. A bird is stalked, it flies and it has its photograph taken. Are we caring as much for the bird's welfare as we might? We stop it from feeding and make it use up fuel that it might use for surviving a cold night or making a

migratory flight? The flight of a bird at the approach of a photographer shows 'fear' in a very positive and identifiable way.

So far we have been concerned mainly with Rule 1 of our code . . . i.e. the bird's welfare must always come first. Rules 3 and 4 are not central to our debate and can be agreed by all protagonists. Rule 2, 'the animal to be photographed is wild and free', like Rule 1, poses real problems. In our view the elucidation is closely linked with that of Rule 1.

A bird that returns to its nest without force could be said to be 'wild and free'. But it could equally be argued that it is being constrained by human exploitation of its basic drives. The facts are that many photographers do take pictures of captive subjects. Almost all small mammals are photographed in this way but there is no outcry, perhaps because they are so difficult to work in the wild. Many birds in many countries would still be unphotographed today were it not for work on captive subjects. South America with its 2,000+ species awaits the enthusiastic bird photographer.

In instances where no photographs exist most of us would be prepared to stretch a point and allow controlled photography while hoping that eventually the birds would be worked in their wild and free state. But taking the argument a stage further there are shots that, while not of unphotographed species, show aspects of behaviour that have not been photographed before. The work of Greenewalt on hummingbirds comes to mind. The drama of the pictures, as well as the increase in our knowledge of aerodynamics, justifies the technique of using controlled subjects.

Having got this far we have allowed that wildlife photography is not confined to subjects that are wild and free. While wanting to obtain photographs of animals behaving as they would if we were not there, we can never know whether we interfere or not and thus whether the animal is behaving naturally or not. We have agreed that in some circumstances, say for scientific purposes, photographs should be taken of captive subjects. But some strange things can be done (and are done) in the name of science. In our field it need not be the first

photograph of a species ever taken. It might be the first of a particular sub-species, the first of a juvenile, perhaps the first showing a unique method of obtaining food like that of the Galapagos woodpecker finch. Can these subjects justifiably be photographed under controlled conditions, or shall we have to miss out this type of subject altogether. Most of us would be prepared to allow some controlled work. The problem is where to draw the line?

Granted that photographs of animals obtaining their food are of scientific interest and that it is often necessary to obtain these shots under controlled conditions, then we must be prepared to allow the photographer to put predator and prey together. With the woodpecker finch only grubs are involved; with shrikes we must provide grasshoppers; with owls we offer mice; but with leopards we have the heart searching problem of having to confine a zebra or gazelle with the cat. Somewhere along this spectrum of subjects most people have drawn the line. The point is that drawing the line anywhere is not a logical thing to do. If it's wrong to put cats and their prey together for photographic purposes, it is wrong to offer a shrike a grasshopper to get a picture. Nevertheless most of us would have few qualms on this score. What has happened here is that we have simply arrived at a point of balance of values. While we think that the death of a grasshopper is to be regretted, we place more value on the photograph showing how shrikes impale their prey. Whereas no photograph, no matter how dramatic or scientifically revealing, is worth the cruelly contrived death of the zebra, even though it happens every day in nature.

What we have here is a simple, almost utilitarian, view of morality. When we take photographs in the wild we always seek to minimise the discomfort of the subject. We approach a bird on its nest with care for its well-being, moving the hide up slowly. Inevitably the subject is hesitant, but eventually settles down and ignores the structure. Similarly we do everything in our power to make a captive subject at home and at ease. But we do inflict some discomfort when the animal is caught and confined and before it has the chance to settle

down and accept its new home. Even this discomfort we have to justify to ourselves in terms of the photographs obtained. If we get really great shots then the minimal discomfort inflicted on the subject is justified, but under no circumstances should an animal be subjected to an ordeal or even gross discomfort. It is not so much what is done but how it is done. A technique in one set of hands can be perfectly acceptable both to us and to the subject. In different hands the same technique can be downright cruel.

Having cleared the way, as it were, we are now able to allow photography of captive subjects as long as it does not distort nature and does not offend our cruelty ratings of the animals involved. It may seem that science has it all its own way. Why should not artistic grounds be regarded as a justification for captive photography. Why not indeed! Why should a great photograph not be taken under controlled conditions—one that sets the subject against its appropriate background—indeed the perfect portrait.

At this point many become doubtful—perhaps because wildlife has tended to become the preserve of the zoologist, ecologist and other scientists. Yet many of our predecessors, as well as some prominent contemporary conservationists, approached wildlife in essentially artistic terms. Indeed the great wildlife photographers have all been great artists. Yet this nagging doubt remains—can one justify anything in the name of science or not?

The trouble with morality is that there are no rules that emerge as conclusions. Thus the reader has still not been told what he might, or might not, take as a wildlife photograph. It is his choice and his decision alone to make. We would, however, like to say what we think!

We feel that tying down captive wild animals to be preyed on by other captive animals is unethical. We feel that allowing large prey to be cornered simply by virtue of being placed in captivity is similarly not allowable. We additionally feel that it is the responsibility of the photographer to label clearly all photographs taken in captivity and not to pass them off as wild and free. We are concerned with truth. Truth in taking and

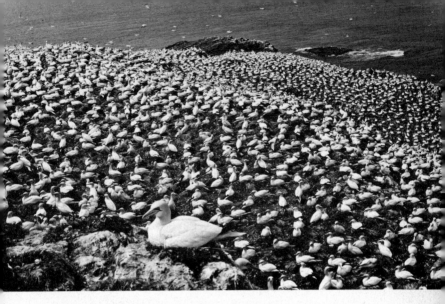

Gannets congregate in their thousands at a few chosen localities and are so tame as to present a wide variety of poses

Stone curlews are scarce and sensitive in the extreme and must be sought out and approached with great care

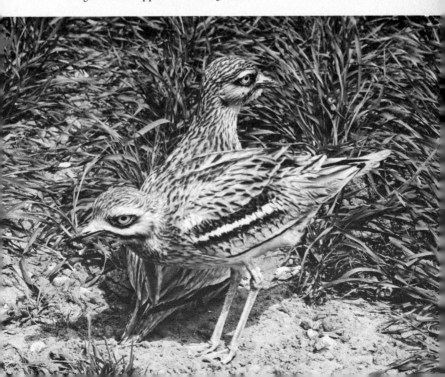

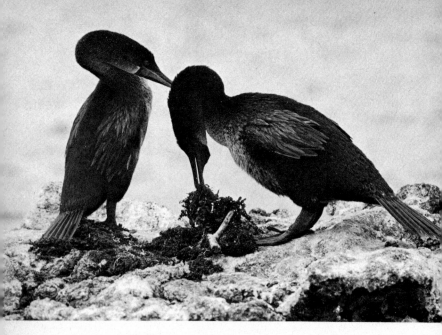

Series of photographs show better than any description the elaborate dance of a courting pair of flightless cormorants

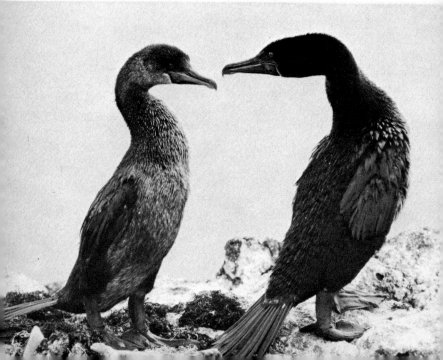

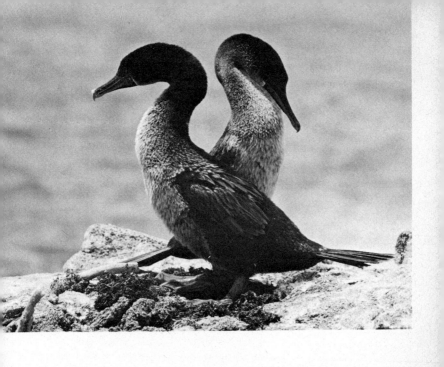

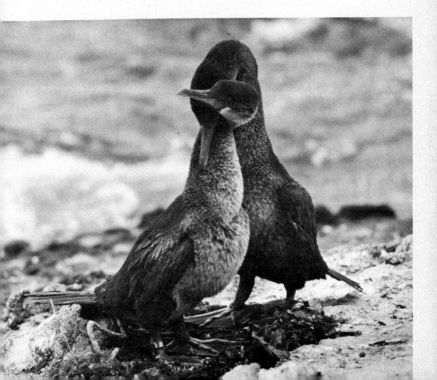

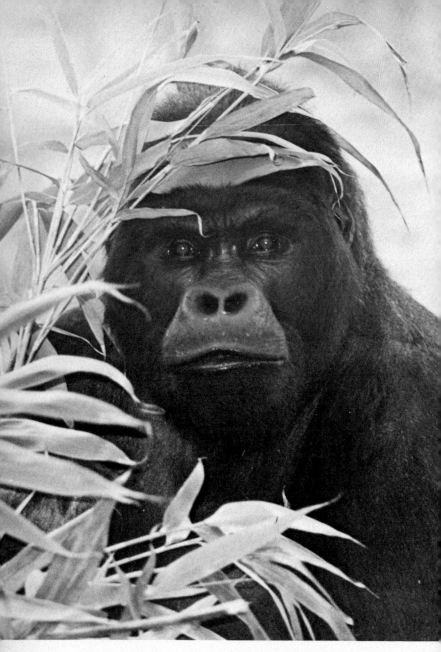

A male mountain gorilla shows how the zoo shot can be made to look
natural and appealing with a little care and good fortune

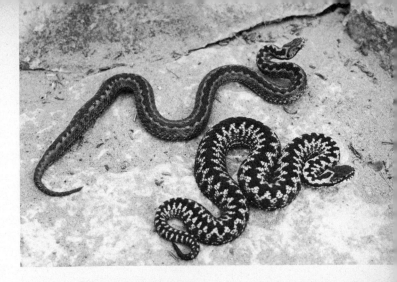

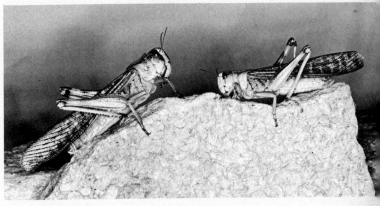

Three stages of close-up work.
Male and female adder shown
side by side for comparison. The
migratory locust requires a closer
approach to reproduce the
creatures almost life-size. An
even closer approach shows
acarina on the ear of a barbastelle
bat

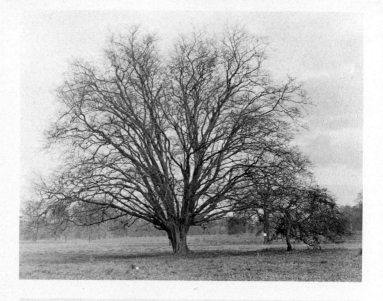

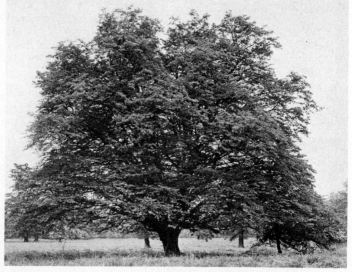

The same tree, taken from the same position at different seasons, makes for interesting comparisons – hornbeam in splendid isolation

opposite : Record every part of the tree: catkins, fruit, leaf and bole of hornbeam

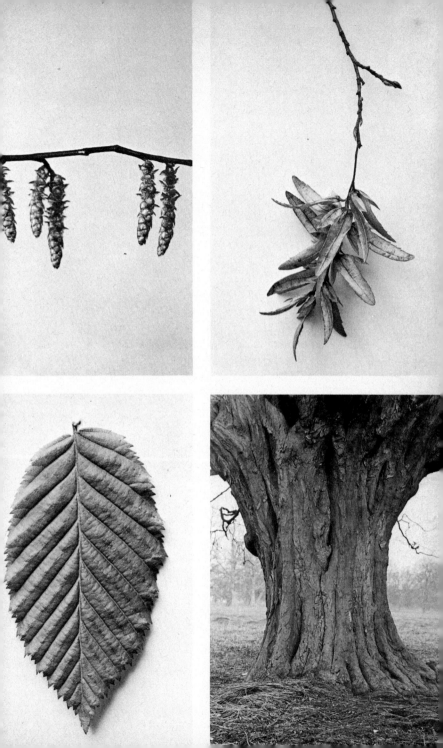

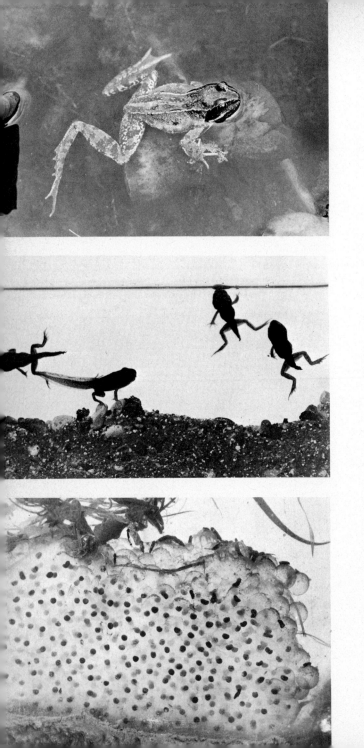

truth in showing. Only what is true of animals, whether taken in captivity or not, can really qualify as wildlife photography. Likewise we condemn the setting up of dead and mounted specimens, and particularly the propping up of injured mammals and birds in natural poses and passing these results off as 'wildlife' photography. The motive in such cases is simply monetary reward from the big business that natural history photography has become—most workers of captive subjects are seldom so obviously motivated.

opposite: *Photographs of smaller animals should attempt to capture the complete life cycle of the species, as with this series of the common frog*

Appendices

Appendix A

Checklists of Equipment

It is a good idea to keep a checklist of all equipment you need to take out each day. There is nothing more infuriating than to arrive at a hide or safari mini-bus and to discover that some essential piece of apparatus has been left behind. Here is our list based on the cameras we normally use, but we should make it clear that we do not normally take out both 35mm and $2\frac{1}{4}''$ equipment at the same time.

Safari—day trip in mini-bus

35mm (Olympus OM)
Camera
Lenses: 50, 300 and 400mm
Lens hood
Extension tubes
Shoulder grip
Bean bag
Film Stock:
 Kodachrome 25 and 64
 H. S. Ektachrome
 Panatomic X
 Tri X
Binoculars

*Note-book and ball point
 (or electronic notebook)

$2\frac{1}{4}''$ square (Hasselblad)
Camera
Lenses: 80, 350 and 500mm
Spare magazines
Pentaprism
Lens hood
Extension tubes
Exposure meter
Shoulder grip
Bean bag
Film stock:
 Ektachrome X
 H.S. Ektachrome
 Tri X

*Note-book and ball point
 (or electronic notebook)

*We prefer a ball point as a pencil has the habit of breaking and a fountain pen of running dry. We have found that the electronic notebook is by far the best way of keeping records in the field as it is almost impossible to write on the move in a mini-bus. Failure to keep a record of the subjects photographed may make it impossible to identify them afterwards.

For Working a Hide

35mm (Olympus OM)
Camera
*Lenses: 50, 135, 300 and
 400mm
Lens hood
Extension tubes
Cable release
Flash set and fittings
Film stock:
 Kodachrome 25 and 64
 H.S. Ektachrome
 Panatomic X
 Tri X
Binoculars
Tripod
Seat and cushion
Note-book and ball point
Flask and sandwiches

2¼″ (Hasselblad)
Camera
*Lenses: 80, 150, 250, 350
 and 500mm
Spare magazines
Pentaprism
Lens hood
Extension tubes
Cable release
Exposure meter
Flash set and fittings
Film stock:
 Ektachrome X
 H.S. Ektachrome
 Plus X
 Tri X
Binoculars
Tripod
Seat and cushion
Note-book and ball point
Flask and sandwiches

N.B. A medium-brimmed hat will not only protect you from sunstroke but also shield the eyes so that you can see more clearly through the view-finder of your camera.

*If the hide is being used for nest photography then it is probable that the long focal length lenses will not be required. The point of taking the normal focal length lens is because it is likely a habitat shot will be required or one of the nest and eggs.

Appendix B

Circuit of photo-cell trigger unit

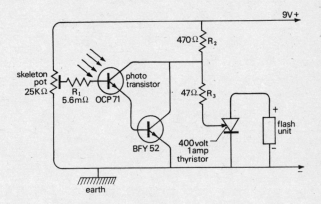

Figure 15. Wiring diagram to show circuit of photo-cell trigger unit. If 'trigger' is constructed and tested, and gives no immediate response, make R3 variable and repeat test, as components vary (Courtesy Alan Parker)

Appendix C

**Birds on Schedule 1
of the Protection of Birds Acts 1954–1967**

Under the 1954–1967 Protection of Birds Acts a group of British birds was given special protection in addition to the general protection afforded all birds. Though it applies only in the United Kingdom, the list is given below for the guidance of all photographers who wish to work in this country. The species listed may not be wilfully disturbed at or near the nest and may be photographed only with the permission of The Nature Conservancy Council, 12 Hope Terrace, Edinburgh, EH9 2AS. Under the Acts the Conservancy may extend or amend the list according to circumstances.

Protection of Birds Acts 1954 to 1967

First Schedule to 1954 Act as amended

Part I. Wild birds and their eggs protected by special penalties at all times

Avocet	Crossbill	Greenshank
Bee-eater, all species	Diver, all species	Gyrfalcon
Bittern, all species	Dotterel	Harrier, all species
Bluethroat	Eagle, all species	Hobby
Brambling	Fieldfare	Hoopoe
Bunting, snow	Firecrest	Kingfisher
Buzzard, honey	Godwit, black-tailed	Kite
Cetti's Warbler	Goshawk	Little Gull
Chough	Grebe, black-necked	Mediterranean Gull
Corncrake (landrail)	Grebe, Slavonian	Merlin
Crake, spotted	Green Sandpiper	Oriole, golden

Osprey
Owl, barn
Owl, snowy
Peregrine
Phalarope, red–necked
Plover, Kentish
Plover, little ringed
Purple Heron
Quail, European
Redstart, black
Redwing
Ruff and reeve

Sandpiper, wood
Scarlet Rosefinch
Serin
Shorelark
Short-toed
 Treecreeper
Shrike, red–backed
Sparrow-hawk
Spoonbill
Stilt, black-winged
Stint, Temminck's
Stone curlew

Swan, whooper
Tern, black
Tern, little
Tern, roseate
Tit, bearded
Tit, crested
Warbler, Dartford
Warbler, marsh
Warbler, Savi's
Woodlark
Wryneck

Part II. Wild birds and their eggs protected by special penalties during the close season

Whimbrel

Wild duck of the following species:

Common Scoter
Gargany Teal

Goldeneye
Long-tailed duck

Scaup-duck
Velvet Scoter

Further Reading

Though this guide is almost entirely the result of the authors' own experiences in the field, we have worked with so many people in so many places, confronted so many new situations, and discussed the problems with so many good companions, that it is almost impossible to say who thought of what. Techniques have evolved in the field and doubtless good ideas have been adopted from the written works of others. A full bibliography acknowledging our debts would be impossible to compile. Nevertheless, some recent books will, we think, be of considerable value to those wishing to go further in the various branches of wildlife photography.

Heather Angel: *Nature Photography*, Fountain Press, London, 1972.

Bruce Campbell and James Ferguson-Lees: *A Field Guide to Birds' Nests*, Constable, London, 1972

John Gooders: *Where to Watch Birds in Europe*, Deutsch, London, 1970
Wildlife Paradises, David and Charles, Newton Abbott, 1975

Prepared by Jean-Paul Harroy: *United Nations List of National Parks and Equivalent Reserves*, Hayez, Brussels, second edition 1972

D. M. Turner Ettlinger (Ed.): *Natural History Photography*, Academic Press, London, 1974

Christopher Parsons:　　　　　*Making Wildlife Movies*,
David & Charles,
Newton Abbot, 1971.

The Editors of Time-Life:　　*Photographing Nature*,
Time-Life,
New York, 1971

John Warham:　　　　　　　*The Technique of Wildlife
　Cinematography*,
Focal Press,
London, 1966.

John G. Williams:　　　　　*A Field Guide to the National
　Parks of East Africa*,
Collins,
London, 1967

Index

Compiled by Gordon Robinson

Italicised numbers refer to figures in the text